sona
BOOKS

**First published in the UK 2021 by Sona Books
an imprint of Danann Media Publishing Ltd.**

Copy Editor Tom O'Neill

CAT NO: SON0436
ISBN: 978-1-912918-03-4
Made in EU.

The Complete Guide to improving your

Painting & Drawing

Contents

Bitesize tips

Whether you have half an hour or an afternoon to spare, follow these quick, simple and fun tips and start experimenting with your art today

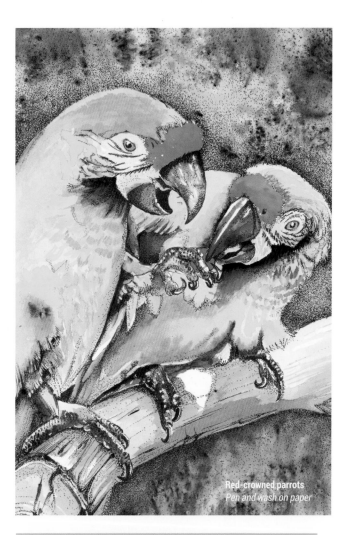

Red-crowned parrots
Pen and wash on paper

Experiment with Brusho ink pigments

BRUSHO is a highly concentrated watercolour ink powder. The pigments produce vibrant colours, but can be toned down with water. It's a very versatile medium, which suits our colourful subjects well! Here, I will take you through a selection of techniques that create some very interesting effects.

Shake it all about!

Punch holes in tub lids with a darning needle and sprinkle the pigment like a salt-shaker. Use a spare piece of watercolour paper to test the strength or shade of your colour before committing it to your work.

Follow these steps...

1 I've drawn my image using a DotsPen on watercolour paper using permanent ink, so that it doesn't run when the colour is applied. I've applied masking fluid for areas that I want to keep white, as well as a wax resist for more broken areas.

2 Brusho can be messy, so I use tracing paper to create a mask to cover the birds while I paint the background. I wet the area and sprinkle the dry pigments so they 'bloom' in the water. This gives an abstract result – you'll never get the same result twice! Use water to dampen the paper more, if it needs it.

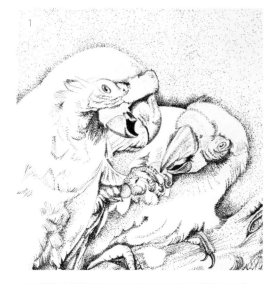

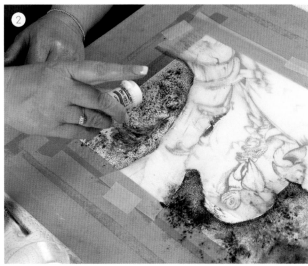

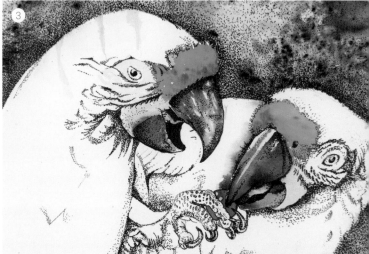

3 I want to pick out the heads and feet in a fairly detailed way to contrast with the background, so I switch to a size 2 brush and use the pigment more like watercolour. I mix it with water and work from light to dark on the beaks and face. For the most vibrant areas I use pure pigment and just touch it into the damp paper

4 For the main green of the parrots and the brown branch, I lay a flat wash, varying the colour strength or overwashing grey to define form. I use dry pigment on a flat brush and work into the damp areas to stipple in the texture. Finally, I strengthen the dark areas to punch out the contrasts. I remove any masking when the piece is completely dry.

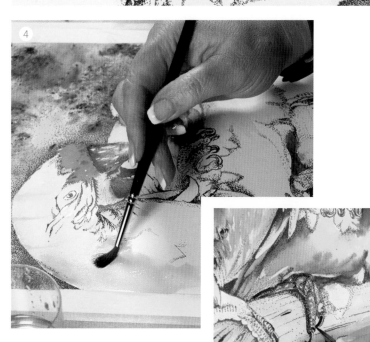

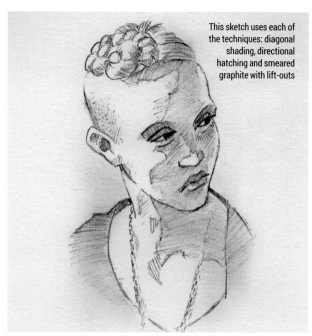

This sketch uses each of the techniques: diagonal shading, directional hatching and smeared graphite with lift-outs

Combine different shading techniques with graphite pencil

THERE ARE MANY WAYS to create shading effects with graphite, but it's also effective when you combine several techniques. It can add more personality and diversity to your sketching. Many distinctive techniques overlay and interact with each other, which in turn can help inspire you as you explore your image.

Since I was a child, I shaded with all my strokes in one diagonal direction. However, a few years ago, I began to use hatching-style strokes with a more constructed, less organic feeling. That offered some interesting results, and made me more receptive to trying other techniques. Recently, after seeing some thumbnail sketch examples that I liked the look of, I've experimented with smearing the graphite with a sponge or my finger, and lifting out areas using a shaped kneaded eraser. This can be quite distinctive and lovely, and playing with lost edges brings even more character to this style.

As you gather together different shading techniques, elements of each one will begin to show up in your regular work, and you'll find yourself with more options to work with when it's time to resolve the different parts of your drawing.

Follow these steps...

1 This diagonal shading style feels the most comfortable to me. I like how directional lines help unify a piece. I find this style can help when you're working out value structure, and it's nice to keep the pencil moving fairly continuously. However, the downside is it can get a bit indistinct in tightly detailed areas, and maybe feel a bit staid.

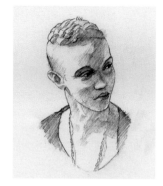

2 This hatch style with widely spaced, deliberate marks tends to abstract out the different areas of tone. It's distinctive, but it does require more planning ahead as well as control. You can sometimes lose your way if focus goes astray. These kinds of marks can often bring some energy into the drawing. You can easily direct the viewer's eye within the image.

3 Smearing the graphite can give quite an ethereal effect, and it always gives me new ideas about the sketch. Here I've reduced nearly everything to white, black and an extensive middle tone. I shape the tip of a kneaded eraser by hand to lift out areas for highlights and special effects. I also pay attention to where I can lose edges to good effect. It's a really fun technique!

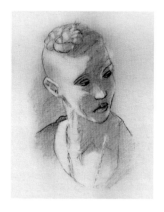

Sand it down!
Some pencil sharpeners can break leads. I use small sandpaper pads for varied tip shapes – I can get points, flat edges and more. Plus you get longer life from your pencils!'

Paint vibrant petals in watercolour

FLOWERS are always lovely subjects to paint, but their complex petals can often be difficult to get right. By looking at the contrasting effects of highlights, midtones and shadows on a single petal, I will show you how to get a more realistic, tonal appearance with just a few techniques, and only three basic mixes on the palette.

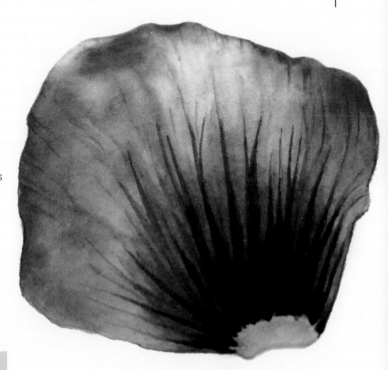

With the fine details introduced, the complex tones and highlights emphasise the shape further, giving a more realistic finish

Mixing Shadow Tones

I always mix my own shadow tones using transparent red, blue and yellow. Mixing the three primary colours together will always create black. Many premixed greys contain opaque pigments that can dull a mix.

Follow these steps...

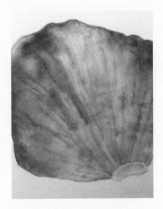

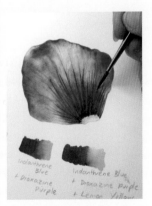

1 After laying a glaze of clean water, I drop in the lightest colour. While the glaze is still wet, I continue to build up the tone where I need to by adding more touches of paint several times. Lifting colour with a clean, damp brush maintains any highlights and softens the finish. Let each layer dry, before applying the next.

2 Now onto the midtone. This will form the actual colour of the petal. Working as before, I let the water glaze settle, before dropping in the second colour. Keeping the paint away from the brightest highlight, I leave plenty of the first wash visible. Again, I use a clean, damp brush to lift off any unwanted colour.

3 Shadows offer the deepest tones, and will give the petal a three-dimensional appearance. Another glaze helps the darkest paint spread, softly building the deeper tones, and creating higher contrast and tone. With more variation and contrast it will look more lifelike. At this stage, wet-on-dry details can also be introduced.

4 Working wet on dry, I apply the deepest colour only where I want it. This builds more depth and movement with several layers of paint. I also soften the edges with a clean, damp brush. The characteristic markings are softened with several complex overglazes, made by mixing the hues on the palette together.

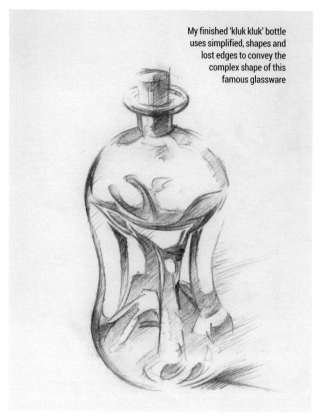

My finished 'kluk kluk' bottle uses simplified, shapes and lost edges to convey the complex shape of this famous glassware

Sketching glass in pencil

GLASS EFFECTS can be intimidating to re-create. Many artists will do detailed renderings, but it can be difficult to keep focus over long tasks like that, picking up on every subtle difference and effect. Here, I observe my subject – a shapely glass bottle – and break it into areas of bigger shapes, giving a pleasing effect with much less work!

DAVE BRASGALLA

Push and pull
'Lost' edges can really elevate a piece. Look for places where this technique can aid your image – observe your reference closely, but loosen up where possible when rendering it. Our minds really enjoy completing the elements on our own!

Follow these steps...

1 For an interesting subject, I'm using an antique Holmegaard bottle I own – the so-called 'kluk kluk' bottle, named after the sound it makes when pouring. They're gorgeous, strange and lots of fun! I start by marking out the general shape of the bottle, and the outlines of the bigger shading areas. I've already decided where I'm going to lose some of the edges.

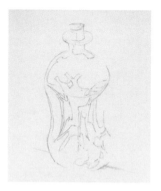

2 I'm aiming to have, roughly, a three-value structure with the paper as white, greyish mid-tones in HB pencil, and dark accents created with a 4B pencil. I'm keeping the mid-tone fairly uniform here, and will taper it off to white where some deeper shadows occur on the real bottle. This reversed-value effect will help the glass feel more filled with light.

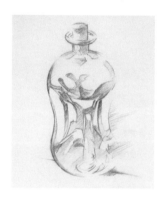

3 I have now captured most of the effects – so, I've started to hack in some darker areas with the 4B pencil. I also decide to take some shading areas right outside of the bottle's shape. This kind of technique helps keep me from getting too literal. I'm also working to stay bold with my mark-making, and not devolve into 'noodling'.

4 At this point, I felt some areas had become a little too fussy, so I went in with shaped kneaded eraser to lift out and clean up a bit. I also look around for any other edges I can lose. Lastly, I go back in with the 4B pencil in order to really push some dark values that I hope will help guide the viewer's eye around the image.

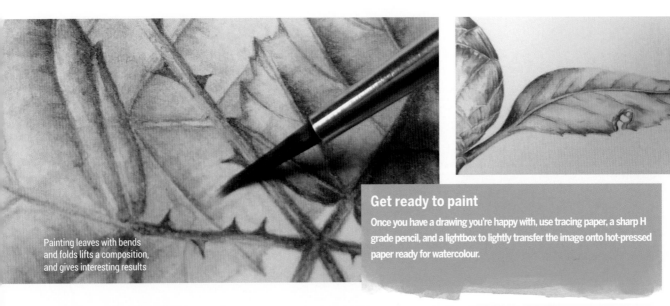

Painting leaves with bends and folds lifts a composition, and gives interesting results

Get ready to paint

Once you have a drawing you're happy with, use tracing paper, a sharp H grade pencil, and a lightbox to lightly transfer the image onto hot-pressed paper ready for watercolour.

Observe leaf structures clearly

DRAWING BENDING LEAVES can be difficult to get your head around, but here I show you a neat little trick I picked up from a fellow painter. It will help make your drawings more accurate, as you see how the direction of even the most intricate of vein patterns change as the leaf bends and folds.

Follow these steps...

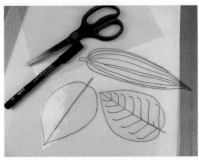

1 Use a permanent marker pen to draw a range of shapes on clear acetate. Always start your leaf drawings with the centre vein as this will ensure a more accurate representation. If you try to put in the centre vein after you have drawn the outline, it can look unrealistic. Now cut out the shapes.

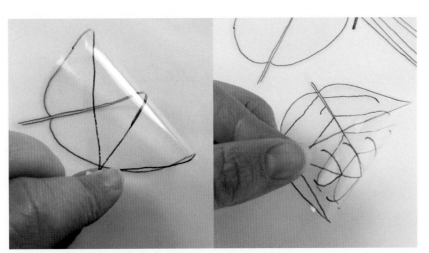

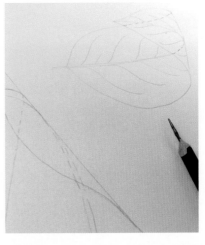

2 As you manipulate the shape, you will see how the centre vein changes direction, or disappears behind the folding surface, while remaining connected. After starting with simple shapes, move on to leaves with more complicated vein patterns. Note how the direction of the lateral veins change once the leaf is bent.

3 You can now practice drawing the leaves with different bends and folds, using the acetate shapes as a guide. Draw all the lines you can see, even the ones that will eventually become invisible against the surface of the actual leaf. Any lines you no longer need, can be erased, and you will be left with a more solid shape.

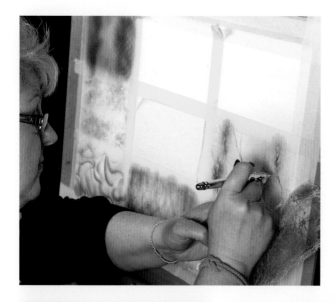

Creative textures with an airbrush

WORKING with an airbrush requires some out-of-the-box thinking, but the end results can be rewarding.
If I'm ever caught studying pan-scourers, rest assured it's got nothing to do with the washing up sitting in the kitchen sink – I'll be working out if I can spray through them to create some wonderful texture! After this, shopping trips will never be the same again...

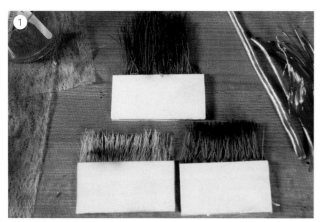

Follow these steps...

1 These are just some of the items collected or made that create great textures. Broom bristles are great for developing hair or fur, while pan-scourers make for fantastic rocky surfaces. Florists often wrap bouquets in interesting textured fabrics that are useful for spraying undergrowth tangles. Gather a selection of such items, divide a work-board into sections with masking tape and start experimenting.

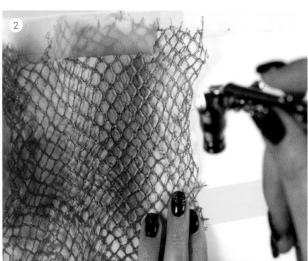

2 Materials, such as this bag that once held some satsumas, might need taping in place to keep them flat against the surface. This will ensure that you develop a crisp edge. Try out different colour layers and see what happens when you spray through another texture layer. Take care not to saturate the fabric that you're spraying, though. Use short bursts to keep it relatively dry, and wipe any excess off on a piece of kitchen towel.

3 Transparent Mylar sheets are useful for creating your own stencils or shaped shields. You'll save money and it's more rewarding, too. If you want to develop sharp edges in your art, shields are best held flat against the surface. Holding a shield slightly off the surface will diffuse an edge. Spray onto the edge of the shield and let the overspray do the work.

4 Using masking film enables you to overspray areas safe in the knowledge that you won't ruin the piece. I cut out and remove the pebble shapes, then use a lolly stick or old pencil to bounce the overspray to create a very effective spatter effect. Remove the background film and cover the pebbles with the pieces you removed, then spray the shadows without affecting the pebbles.

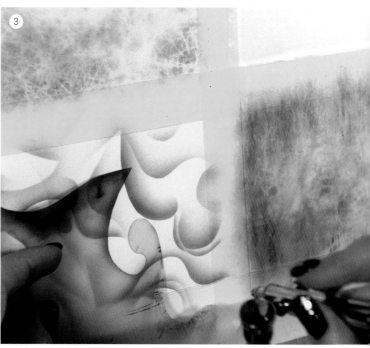

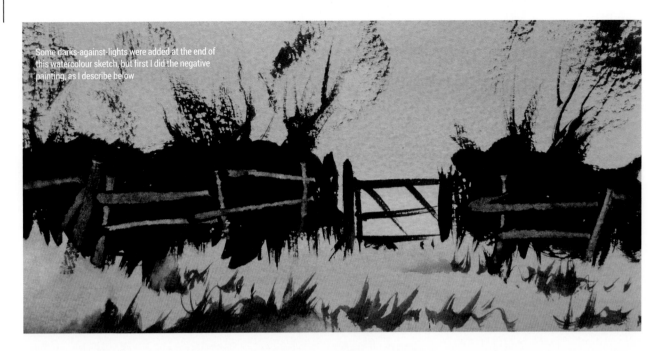

Some darks-against-lights were added at the end of this watercolour sketch, but first I did the negative painting, as I describe below

Negative painting in watercolour

NEGATIVE PAINTING refers to painting the negative shapes that define positive ones. This is especially important with traditional watercolour, where painting things as light-against-dark means the white of the paper must be preserved (rather than using white paint as is done with opaque media). So, instead of painting the object, you paint the object's background.

Follow these steps...

1 This is a simple demonstration of a useful exercise. First, paint a rectangular section of paper with a two-colour wash, blue at the top and a pale hay colour at the bottom. They can blend together for a soft-edged join. Don't worry about perfection, but aim for half and half of each colour. Now let the paper dry completely.

2 Using a thick dark-green mix and a large synthetic brush (which will enable you to work quickly), paint in two bits of hedgerow. These overlap where the background colours merge. You can draw the main shapes in pencil first if you like, but here I'm just drawing with the brush, which is good practice for mark-making.

3 Now use a combination of downwards and upwards brush strokes at the bottom of the hedge sections. Here you're defining the long grass and weeds in front of the hedge, and you have to think negatively while being quick! In addition, paint a gate, posts and some growth on top of the hedge. You need to do all this while the paint is still wet.

4 Here's another negative-painting method for some fence posts. First, briskly make horizontal and vertical scrape marks in the still-damp hedge. I find a fingernail works well for this, but you could try anything hard, such as a matchstick. The relatively thick paint will lift off to reveal the underlying wash, and voilà – you have your lights-against-darks!

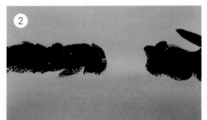

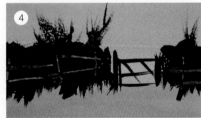

Tips and tricks for cleaning your airbrush

CLEANING AN AIRBRUSH can seem fiddly if you're not used to it (and it can be expensive if you get it wrong). Here, I provide some helpful tips to make the whole process easier.

Follow these steps...

1 First set up your working space. Make sure you have everything you need to hand. I use two clear pots: one to hold the cleaner and the other for the water. If the cleaner is clear in colour, label the pots, so you can tell the two apart.

2 Your airbrush should have an assembly diagram with it. If not, you ought to be able to find one for your model on the internet. It'll come in useful if this is the first time you've taken it apart. Remove the needle and clean any paint off with an airbrush wipe or kitchen roll dampened with cleaner. Take care not to damage it, then set it aside.

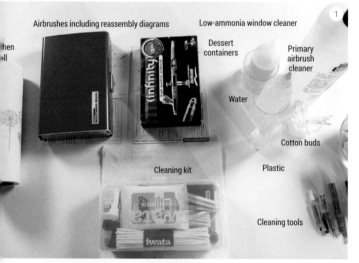

Airbrushes including reassembly diagrams
Low-ammonia window cleaner
Dessert containers
Primary airbrush cleaner
Water
Cotton buds
Cleaning kit
Plastic
Cleaning tools

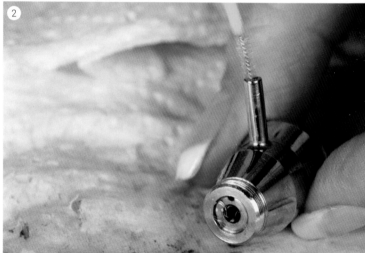

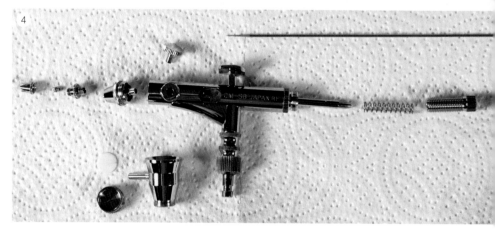

3 Remove each part and place it in the cleaner solution. If you have any stubborn paint residue, soak the parts overnight. Otherwise, soak for about 15 minutes, then remove and clean each piece. Pay attention to the paint cup and nozzle head where the paint pools. Use the specialised brushes dipped in cleaner to scrub out any residue. Drop each piece in the water to rinse.

4 Cleaned and rinsed, it's time for reassembly. Refer to the assembly diagram if you're not clear on what goes where. Don't cross-thread any parts and be gentle when inserting the needle so as not to bend the tip. Connect to the air supply, add water to the paint cup and test your clean airbrush. Finally, blow air through to dry if you're not using immediately.

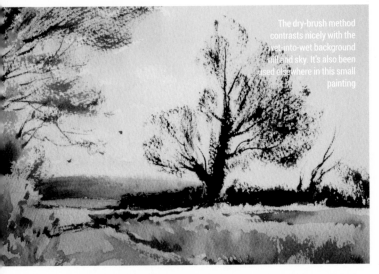

The dry-brush method contrasts nicely with the wet-into-wet background hill and sky. It's also been used elsewhere in this small painting

Paint spring foliage using a dry-brush watercolour technique

THIS PROCESS shows a method for depicting trees when you want your foliage and branches unified as one. It's the effect we generally get when looking towards the light. You'll see less 'internal' detail and variation of tone and colour. Things become silhouetted and it's more the outside edges of shapes that define them.

Follow these steps...

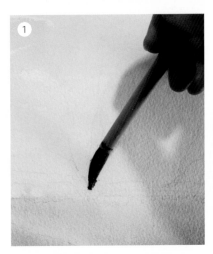

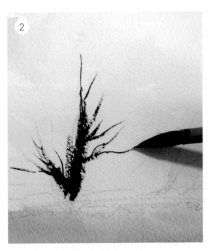

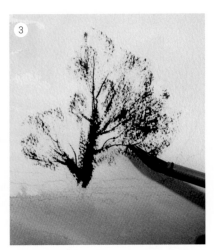

1 It's best to use either rough or NOT surface paper for this effect. Load a medium-sized brush with fairly thick paint. Then begin the tree by squashing the brush against the paper firmly at the base of its ivy-covered trunk. Drag the brush quickly upwards along its length, so it leaves a mark that's broken by the paper surface.

2 Using the tip of the brush, draw out some fine lines as the branches of the tree. However, don't add too many – just think of the biggest branches. At the moment the tree looks like a winter one, but in the next step we'll add the budding spring foliage – you'll see that you don't need to paint hundreds of branches.

3 Next, use the side of your brush without re-loading it, so it's quite dry. Test on some scrap paper first, before dragging the brush across the surface of the paper. If you're happy, start at the outside of the tree and make drags inwards. You may have to press the brush a bit, but go cautiously at first. It can almost be like shading with a crayon.

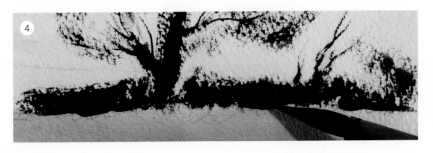

4 Use the same method to describe the hedgerow. Mix up your marks using the side and tip of the brush, pressing down firmly as you drag when you need a stronger, more solid mark. Finally, dampen the brush to enable you to make a cleaner edge along the bottom of the hedgerow where it meets the grass. This will contrast nicely with the rougher top edge.

Blending with coloured pencils

TO GET THE MOST from coloured pencils, we can take advantage of their semi-transparent nature and mix complexity into the tones. Rather than relying upon the individual and flat colour of each pencil, mixing the colours will make things more dynamic. Having some knowledge of colour theory can be useful, but this is also a great opportunity to experiment! In this article, I'll be using a complementary red applied over greens to darken and slightly neutralise the tone.

A top tip on tips!
Vary the pencil sharpness from sharp to dull points for a more random application of colour.

Blend scale (Below left)
Blending and smoothing variations: normal gradient with overlapping colours (left); colourless blender (middle); white coloured pencil (right).

Pressure scale (below)
Pressure will create a noticeable difference in texture. Shown here from left to right: light pressure, normal pressure and heavy pressure.

Follow these steps...

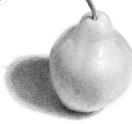

1 Using a light colour, start by drawing the contour of your subject. Using the local colour on the pear is a good way to hide the original drawing. Graphite lines often remain visible and can dirty the colour. Here, I'm working on a white vellum Bristol surface. When selecting your paper, aim for a weight of at least 250gsm, with a medium texture surface and a consistent grain. Smoother paper surfaces won't always take multiple layers of colour.

2 We're working light to dark, so this stage will identify the highlights, lightest tones and establish a base colour that will mix with the layers applied on top. With light pressure and a sharp point, lay a warm yellow over all the pear except for the highlights. I've chosen a cool grey for the shadow at this stage. Avoid pushing so hard that the paper texture is smoothed, because this can effect how additional layers will go down.

3 Continuing to work with a sharp pencil, apply the colours that create a feeling of local colour for the pear – I'm using different shades of yellow-green and green. Looking at mid-tones, the pear is a mixture of colour, rather than a single flat version of yellow-green. Burnt ochre is applied and the shadow is given another layer, this time a warmer steel grey that combines with the original cool grey for more complexity.

4 Finally, darker green, brown, and red-violet are used to define the core shadow and darker parts of the pear. The shadow on the ground has been darkened with layers of blue-violet and dark brown. Lighter colours (slightly grey versions of yellow-orange, yellow-green, and blue-violet) have been applied over top. To finish, lightly use a white coloured pencil to lighten tones. Check if any darks or mid-tones need to be reapplied in some areas.

How to illustrate animal eyes

DRAWING EYES is something that I get asked about frequently. There are some critical, yet simple steps and techniques to remember that will improve the end result.

In this short article, we'll cover those key elements in relation to feline eyes, but the same principles will apply for most animals. I've used pastel pencils on Pastelmat for this leopard piece.

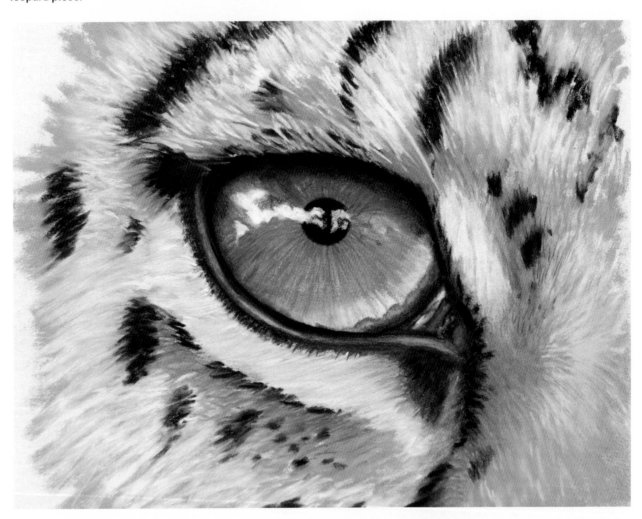

Follow these steps...

1 Being aware of the eye's anatomy will help you understand where everything should be and what happens to the fur or skin covering that area. For example, the lacrimal gland over this eye will cause the fur to curve up and over it ridging slightly, forming the eyebrow and giving a shadow underneath it. I'll reflect that when I add the fur.

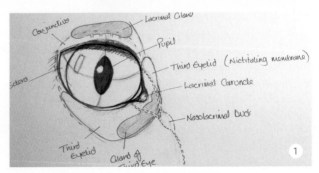

2 This sketch shows how the underlying structures influence form. Remember that the eyeball is a globe, and not a flat disk with the top covered by the upper eyelid. Check the pupil placement on your reference – it's tempting to place it in the centre of the eyeball portion that you can see. Here, I'm using a paper stump to smudge shadows under the lower lid.

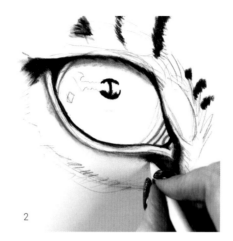

2

3 You'll only see a perfectly round white-dot reflection if the eyeball is reflecting a cloudless sky with bright sun. Typically, the reflection will contain trees or similar structures. I've started to lay in the main colours that I see: blue sky at the top, and a band of white cloud reflection in the iris, which I fill in with a range of ochres.

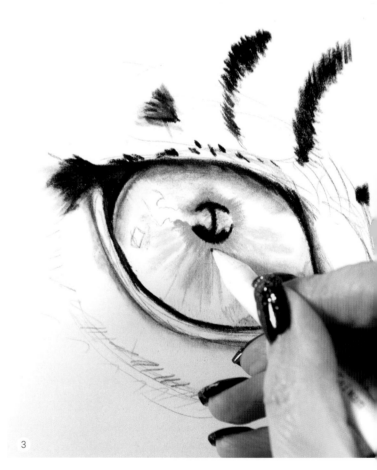

4 At this point you can add in the surrounding texture – in this case, fur. The comparison helps to gauge the strength of the colours in the iris and adjust the values correctly. You'll also be able to see where the shadows and highlights need to be deepened or lightened – typically on the eyeball under the brow, and in the corners.

3

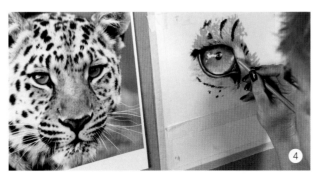

4

Fill your sketchbook with practice pieces

Because your viewer will be drawn to the eyes, you need to depict them correctly. Sketch different eyes to become familiar with their structure. Draw what's there, rather than what you think should be there.

Transfer a sketch with homemade carbon paper

THERE ARE MANY WAYS to transfer a sketch – projectors, printouts, grid systems and so on. But here, we'll use a simple technique with just pencil and paper. Some tracing paper can help to protect the sketch (handy, if you're using an original), and it makes it easier to see which areas you've already traced out. However, if you use a printout, you can trace directly on to that. Your homemade carbon sheet will also be reusable.

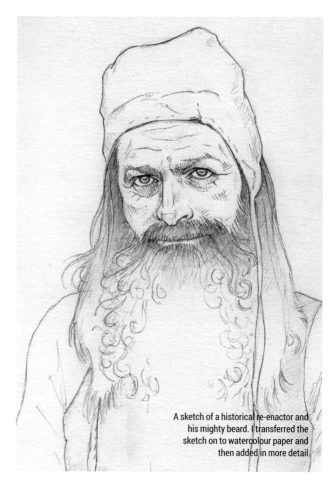

A sketch of a historical re-enactor and his mighty beard. I transferred the sketch on to watercolour paper and then added in more detail

Follow these steps...

1 First I gather the heavy paper I want to transfer my sketch to, the simple copy paper we'll use as the 'carbon paper', a printed scan of my sketch, and a sheet of tracing paper. I also have a thick graphite stick, but a soft-lead pencil will do.

2 Rub one side of the copy paper with the flat edge of the graphite stick. I've covered an area roughly the size of my sketch, but since you can reuse the sheet, feel free to cover most of the paper.

3 I now tape my drawing to the heavy paper, and layer the tracing paper on top. I transfer the important marks and proportions – I'm not worried about exact details. When I'm done, the tracing is faint, but gives enough information to work with.

Use coloured pencils to depict an iris in detail

I ENJOY DRAWING and find the results I achieve from using coloured pencils very satisfying. Whether preparing a sketch for a painting or copying from life on paper, coloured pencils have proved themselves to be very versatile.

I love botanical and floral subjects, and the patterns that are present in the petals of the Siberian iris quickly caught my eye. I couldn't resist buying a bunch of them, with the aim of working on a drawing at home.

Lately I've been using rough paper, but I've chosen a smooth surface for this article because it enables me to better render all the details. I'll use a layering technique and leave only a few areas on the paper uncoloured. After drawing the iris in graphite I start to colour it in.

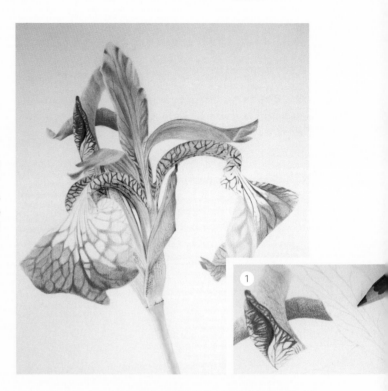

Follow these steps...

1 The dominant colour of this flower is a violet-blue shade, so I tackle all the petal, sepals and tepals in the same way. I start drawing the veins with Sapphire Blue, then go in quickly with a gentle layer of Light Violet to cover all the petal. At this stage it's important to avoid pressing heavily with the pencil. Then I apply a layer of Lavender, emphasising the dark areas that I then intensify with a Violet. I finish with a light layer of Light Blue Sky that helps give a cold blue tone. I draw each layer in a different direction (cross-hatching). For the bud on the left I use Ultramarine Blue for the veins and the outline, then use a Light Yellow and a Light Green for the brighter parts.

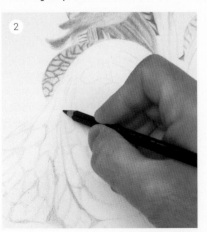

2 The sepals (outer petals) are a complex area. They have a stripy part that I depict with a layer of light Cadmium Yellow. I then draw the veins using Red Ochre, Raw Umber and a bit of Plum, one on top of the other. I use Raw Umber for the area in shade, where the Yellow mixes with the Light Green of the base of the flowers. For the larger parts of the sepals (known as the 'falls', and only two are visible in the foreground) I draw the thick and irregular veins first. I leave the white parts as bare paper, but for the lower part I put down three layers: Light Violet, Violet and Light Blue Sky in the same manner as that used for the upper petals.

3 For the only spathe visible on the left (the leaf of the flower bud), as well as layering it with Light Yellow Ochre, Burnt Sienna, English Red and Natural Umber to mark the outline, I also use some dotting in Brown and Burnt Sienna to re-create its natural unevenness.

4 I colour the stem and the other green parts with a base layer in light green, and then intensify the central part of the stem with Grass Green. I then draw some stripes in the green part at the base of the sepals, before applying some dotting in Burnt Sienna and English Red.

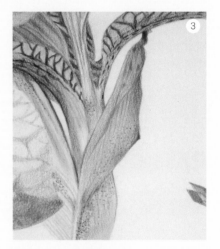

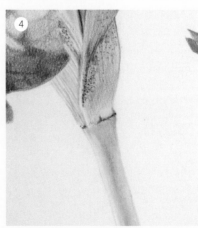

Learn to draw complex objects in perspective

INTERESTING SHAPES often present a drawing challenge, so it's useful to work diagrammatically to establish linear perspective. Here, I've used a seemingly simple takeaway-food carton to demonstrate the principles.

Becoming comfortable with linear perspective can take some time, so be patient. It's worth remembering the following points: keep a fixed vantage point, because a small move will change the perspective; objects appear smaller as they recede into the distance; foreshortening happens when something is rotated away from the viewer; parallel lines that recede into space will converge to a common vanishing point (VP); and finally, in one- and two-point perspective, the vanishing points are commonly positioned at eye level, referred to as the horizon line (HL).

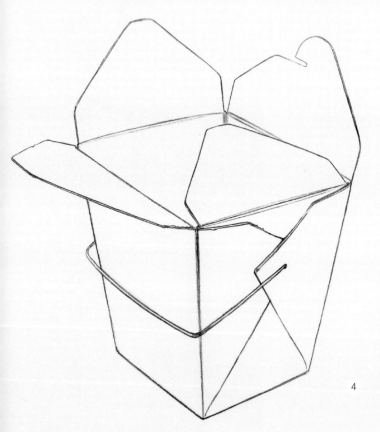

Follow these steps...

1 Start by drawing a basic box for the main body of your object. Use long lines and strokes, extending them further than you need to make sure they converge towards your vanishing points. This tutorial is using two-point perspective, with VPs on the left and right, because there are two dimensions of the box receding away from the viewer. Diagonal lines on the top plane enable me to compare corner relationships and double-check my shape. In later steps the X will be used to locate the mid-points of the planes.

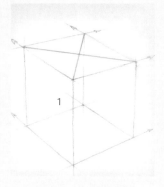

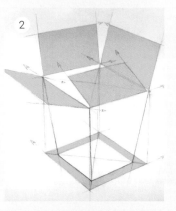

2 Next, the bottom plane needs to be made smaller as the box tapers in width. Start by marking the X from corner to corner of the base. Then draw in the angle of the left or right contour edge so that it crosses the more horizontal angle of the X. Extend your lines from this point around the inside of the bottom plane. On the top of the box, I've created planes to represent the box flaps. Some may be extensions of the box sides, while others may incline or decline, much like a rooftop.

3 After finding the mid-points of the rear two flaps with an X, notice the relationships around that symmetry, such as where the tab touches the edge. The trimmed corners of each flap should line up in perspective. The flap with the tab has a more complex shape, but can be broken into thirds to help when plotting its shape. The right front panel is where the handle attaches and the side flaps fold around and overlap. Establish the mid-point, and then from the top of the side panel bring forward an arc.

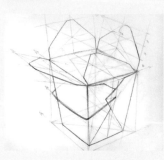

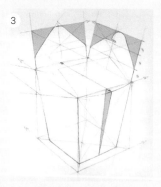

4 Now you can draw the side flaps around the new mid-point. Observe the negative space between the box and the handle as it's attached. I finish drawing the remaining two flaps on top, then give the lines some weight variation. I also add some thickness to establish the cardboard edges, which gives the form more character.

How to paint shadows in watercolour while maintaining transparency

SOMETIMES a fairly unremarkable subject can be transformed into an interesting composition when there's a strong contrast between light and shadow, as in this painting of an old rural building with the sun shining through the bougainvillea. I'll describe how I set about painting the patterns created by the shadows.

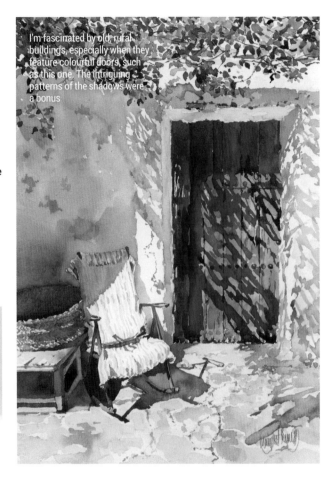

I'm fascinated by old, rural buildings, especially when they feature colourful doors, such as this one. The intriguing patterns of the shadows were a bonus

An alternative to Chinese white

I sometimes use white casein paint , made from milk protein (Pelikan) to correct errors or add finishing touches such as highlights. I dislike Chinese white because of its opacity and tendency to dull colours, and find casein far more compatible with watercolour. Take care not to overuse this technique, though, or the watercolour will gradually lose its transparency.

Follow these steps...

1 First, I make a preliminary drawing that's fairly detailed, but omitting the shadows – I'll paint these last. I then eliminate most of the white of the paper with a transparent layer of Raw sienna and touches of Burnt sienna. When this base is completely dry, I paint the door and the furniture, along with the leaves of the overhanging bougainvillea, leaving blank spaces for the flowers to be painted in later.

2 When I've finished painting the first layers of my composition, I mix the grey with which I intend to paint the patterns cast by the shadows. This mixture comprises Ultramarine blue, Alizarin crimson and Raw sienna and with it, by varying the amount of water and the pigments, a wide range of greys can be achieved. Because I'm using the same pigments for the preliminary painting, I maintain the colour harmony.

3 Shadows need to be painted rapidly and with fluidity of paint. If they're overworked then the effect will be spoilt, which is why I didn't draw them before I began applying the watercolour. The shadows on the walls of the building are painted first. I allow plenty of clean water to flow into the paint while it's still wet to give transparency. Note how the pigments have separated to create a more interesting effect.

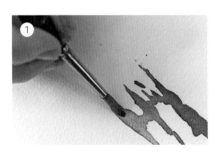

1

2

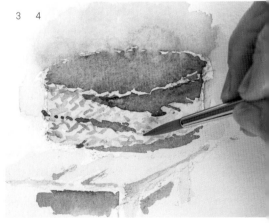

3 4

4 I paint the darker shadows using the same technique as before, drawing the patterns with single brushstrokes and again allowing clean water to flow into the still-wet paint. The advantage of using a limited palette of basic pigments is that you can apply extra layers without the base layer bleeding through, such as in the shadow on the basket. I paint in the bougainvillea flowers with Opera rose (Sennelier) as the finishing touch.

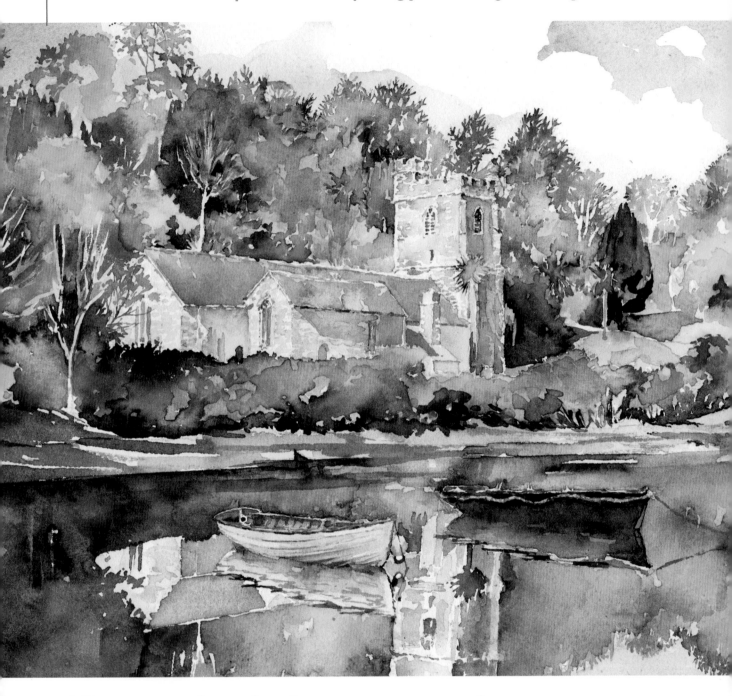

Mix greens from basic pigments for a more natural effect

THROUGHOUT YEARS of working as a professional artist, I have experimented with a number of purchased greens but have always found them unsatisfactory. Viridian is useful, but only for seascapes. On rare occasions I use Hookers Green, but even though it's a fairly subtle colour it can overwhelm more delicate pigments. Here, I would like to demonstrate how a wide range of pleasant greens can be obtained from mixing basic pigments.

Follow these steps...

1 When creating the painting above, the greens needed to be stronger as I approached the foreground. I used Ultramarine mixed with Lemon Yellow and a touch of Raw Sienna, with highlights of Cadmium Yellow and Cadmium Orange. The latter are strong pigments and must be used with care. To vary the intensity of colours, I painted freely using plenty of clean water to dilute the paint. The trees were given a loose treatment to avoid too much detail.

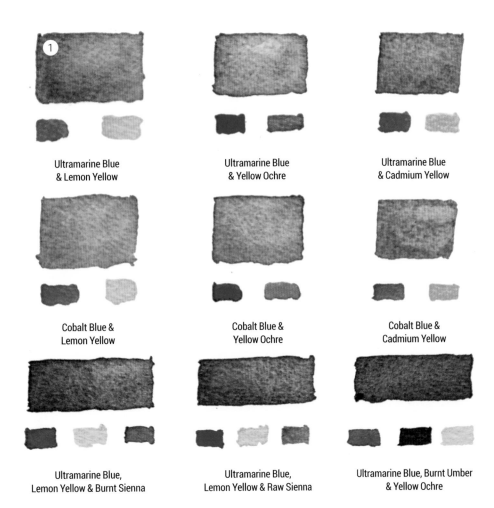

1

Ultramarine Blue
& Lemon Yellow

Ultramarine Blue
& Yellow Ochre

Ultramarine Blue
& Cadmium Yellow

Cobalt Blue &
Lemon Yellow

Cobalt Blue &
Yellow Ochre

Cobalt Blue &
Cadmium Yellow

Ultramarine Blue,
Lemon Yellow & Burnt Sienna

Ultramarine Blue,
Lemon Yellow & Raw Sienna

Ultramarine Blue, Burnt Umber
& Yellow Ochre

2 For the trees and bushes below the church and their reflections in the water, I needed even stronger greens. In order to create a feeling of perspective, I warmed up the colours using Burnt Umber and Burnt Sienna. These pigments blended very well with the Ultramarine mixture and they did not lose their transparency. By allowing clean water to flow into the wet paint, the pigments separated and produced a pleasant effect.

3

3 I wanted soft greens for this painting depicting a Cornish spring but for stronger, summer greens I would have used Cadmium Yellow, as well as Lemon mixed with Ultramarine. Monestial Blue (Phthalo Blue) also produces a strong, bright green when mixed with Lemon Yellow. It's a sharper, more acid blue than Cobalt or Ultramarine and a useful addition to the palette.

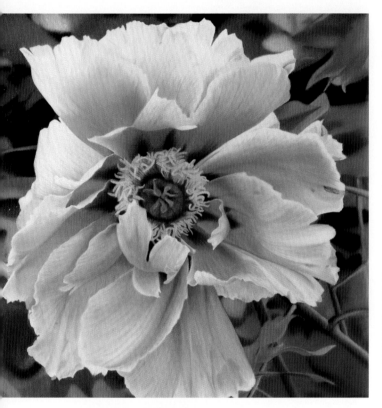

Use grids to quickly enlarge a photograph

THERE'LL BE TIMES when you take a photo of the perfect subject, only to then decide that you want to paint it at a larger size. But what if you don't feel confident drawing it directly onto a canvas, or perhaps are keen to re-create it with exactly the same proportions?

One solution is simply through the use of grids. This method can also be used to enlarge a preliminary sketch, and is a technique that I'll often use in my creative process. Here's how to do it.

All in proportion

Using this grid method, I'm able to transfer or enlarge any photo or sketch onto the canvas without distorting the image's proportion.

Follow these steps...

1 My photo is printed at A4 size on matte paper because I need to draw on it. At this size, all the details are visible. I square off part of the image that I want to paint using a medium-sized marker. The area measures 8x8in. Then, with a thin pen, I draw a grid of 100 squares, each one 0.8x0.8in.

2 I take a 20x20in canvas for my painting and draw a grid of 100 squares on it, each one measuring 2x2in. I make sure to use a hard graphite pencil (from 3H up) and avoid applying heavy pressure. It's important to make sure the lines are barely visible, so that they'll be easier to erase later.

3 Now it's time to start drawing the subject, only this time using charcoal. Make a note of what's in each square on the original, and then copy this into the corresponding square of the canvas. I suggest starting from the top-left corner and working from there, rather than choosing a random square. It's easy to build up the composition following the flower photo and, once completed, it will retain the proportions of the original image.

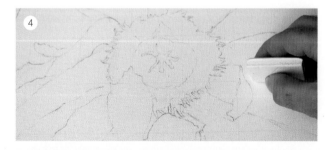

4 Once I've finished the drawing I rub off the grid pencil lines with a soft putty rubber. If you've followed my advice then the lines shouldn't be visible, but don't worry too much if they still are because the paint will cover them up. The sketch is now ready and I can begin putting down the paint – oils in this case.

Paint realistic copper effects

PAINTING METAL EFFECTS is based on the contrast of light and dark in addition to environmental reflections. For this example, I'll take an old copper glass holder standing on a glass surface. Any form is based on alternating tones: midtone-light-midtone-shadow-reflection. But copper also needs to include colour variations, made by combining contrasts and additional colours. The most difficult part is to not get lost in all of those details.

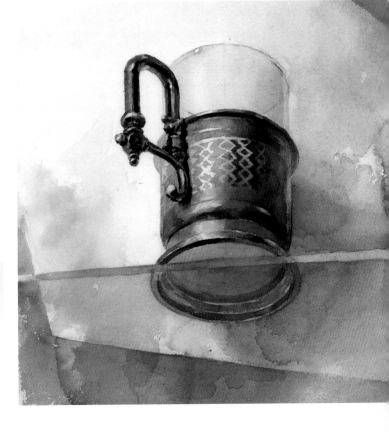

Paint glossy surfaces

When painting glossy surfaces, make the highlights white, or almost white. They should be very sharp and small. Shadows are also small and dark. Midtones are filled with small reflections.

Follow these steps...

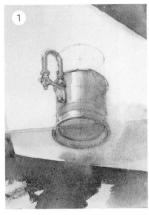

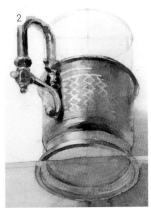

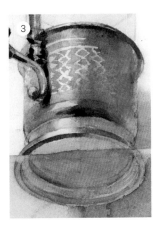

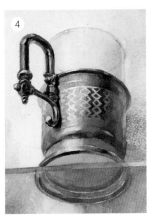

1 On the first layer I place local colours for the object and background. I separate light from shadow and leave the highlights. If paint accidentally gets into a highlight, I remove it with some paper towel. After that I wet the area and dry it with the towel again. The local colour for the glass holder is warm, the background is cold.

2 Now I add engraving. It should contrast to a light part. That's why I paint the engraving as cold and dark while the local colour remains warm. But the engraving should not be darker than the main shadow. Shadows must always remain darker than any contrasts to a light part. Also, no engraving should be visible in the shadows.

3 Here I add warm and cold tones. Copper is full of colours – it varies from yellow, orange, brown, green, cold grey and blue. Highlights may be bright white and shadows are almost black. Because of these variations, highlights will be warm, midtones are cold, shadows are warm, and reflections are cold.

4 At this point I take my smallest brush and paint the tiny details. It is important to assess the whole painting again. I add details and boost contrast in the midtones and shadows. But don't get too bogged down – it is also important to ignore unnecessary details because it will make the painting more expressive.

Use fixative to bring out the colour and energy in your pastel pictures

I'M AN ENTHUSIASTIC user of fixative throughout the development of a picture. From the start, when I'm laying down the background, I fix at every step. Using darker tones (harder), I build up a grainy texture and rich colour. If the pigments are unfixed, they move around and create a dusty, muddy effect, which I find difficult to work on. Once I move on to lighter (softer) tones, the work starts to brighten.

Only at the final stage is the surface left unfixed, showing colours at their full strength. Marks are left more gestural.

Follow these steps...

1 I use artists' soft pastels. The wider the range of the colours and the higher the quality of pastels, the better the result. I like to use fixative liberally and recommend using a face mask, because breathing in too much pastel dust and fixative is unhealthy. Sturdy cartridge paper is a good choice: it won't buckle under the stress of this many-layered process.

2 I begin by placing tape around the edges of the picture. This helps me focus on the scale of the work. It also leaves a crisp, clean frame at the end when I remove the tape. Using the side of the pastels, I cover the surface two or three times with different colours, fixing each layer as I go.

3 This dark but rich background is my way of building up an interesting texture and sets up the lighter, softer colours beautifully. I loosely mark out the shapes and colours of the image and correct freely with the fixative. The colours will drop in intensity after fixing but don't be alarmed. It enables them to be reapplied, adding to their strength.

4 So as to keep the work lively and the colours intense, I leave the final surface mainly unfixed and the last marks are made as spontaneously as possible.

Add dimension to your work with paper collage & acrylic

EXPERIMENT and develop your art with collage and open up all sorts of ways of working. Look at home for paper, such as letters, books, magazines or wrapping paper. You could also buy handmade and decorative paper. Spend an afternoon experimenting on something new that is personal to you. Create layers and texture with paper, glue and paint.

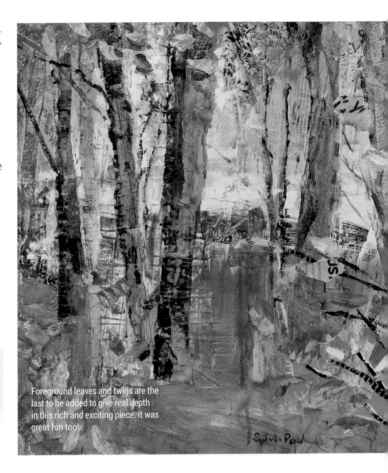

Foreground leaves and twigs are the last to be added to give real depth in this rich and exciting piece. It was great fun too!

Present your work

I always varnish my acrylic/paper collage art with a UV filter varnish. This protects it from light and dust and no glass is required when framing. I work over the edge of the canvas and this gives a neat finish.

Follow these steps...

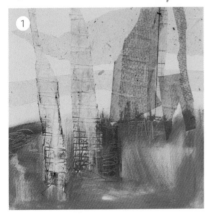

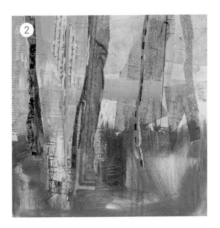

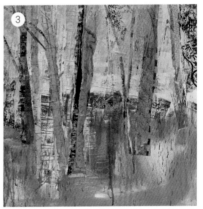

1 A woodland theme is perfect for this textural work. I am using a 12 x 12in canvas but you could use primed board. With PVA glue, I attach torn pieces of textural paper and pages from an old book. I'm not trying to be accurate but just creating an interesting surface. I add acrylic paint and scratch into this to create more texture.

2 More colour is painted over different papers. I have used letters and the edge of an old map. Magazines can provide great colour and interesting text. The paint can be applied thinly, allowing the paper to show through, or thickly to cover it up. I am thinking about the composition here, keeping it free using a large brush.

3 I adjust the tones to create depth. Dark papers or paint provide contrast and some papers are cut with scissors to give a sharper edge. Other areas can be softened with paint. I dry the painting with a hair dryer and use thick acrylic and a dry brush to drag over the textural areas so the underneath colour shows through.

Materials
- Oil paints
- 8x10in panel
- Variety of brushes including sable flats and sable filberts
- Gamblin Flake White Replacement
- Winsor & Newton Liquin Original
- Winsor & Newton Liquin Impasto Medium
- Cobalt Drier

Paint an epic New York scene

Mick McGinty demonstrates how he paints expressive strokes to capture the mood of this impressive structure

For this workshop I'm painting one of my favourite subjects: a New York City bridge. I've painted the Brooklyn Bridge many times now in different light, so for this project I've chosen the Manhattan Bridge.

I grew up reading about New York from my little hometown in the Midwest and have always loved the history and ageless beauty of the city. Since finally visiting for the first time in 2007, I have taken photos of its landmarks to paint.

When you look at a bridge, building or park from New York, you appreciate the hard work that went into constructing it – the detail, style and craft that the labourers of that city put into creating its wonders. These landmarks evoke beloved memories for many people.

When painting these magnificent structures, I look for angles that best fit a certain format. Some subjects work best in a more horizontal format, and some look better in a vertical one. I take many photos to pre-compose paintings in my viewfinder, knowing that I have a great layout for one format or another.

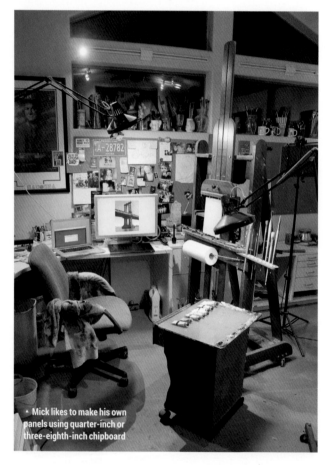

▲ Mick likes to make his own panels using quarter-inch or three-eighth-inch chipboard

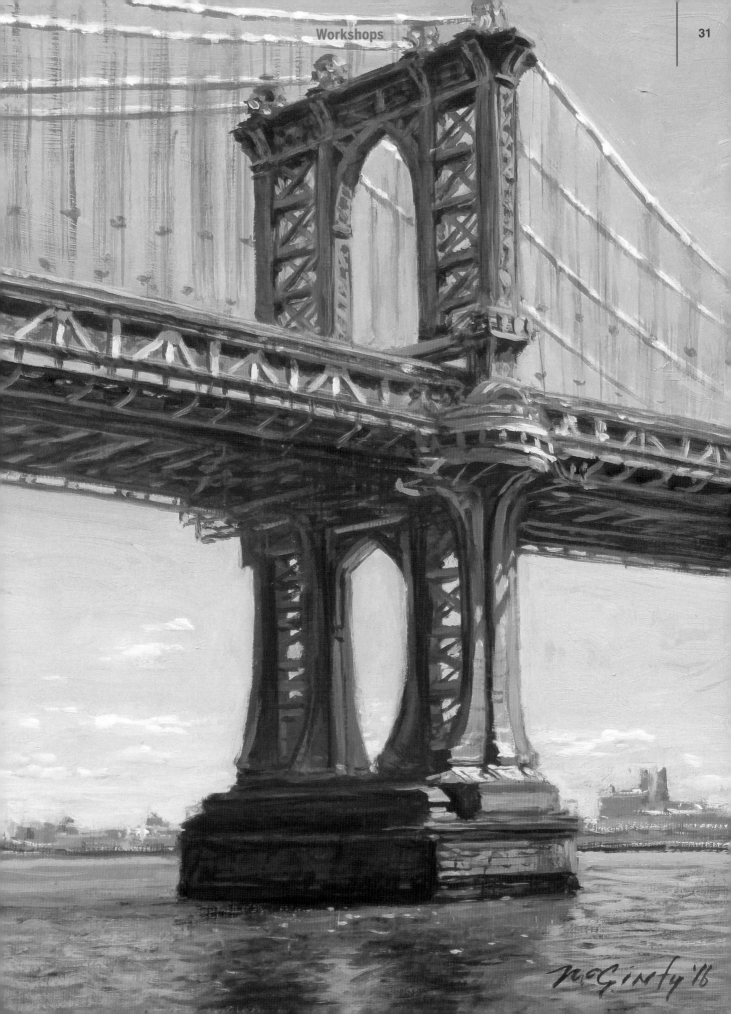

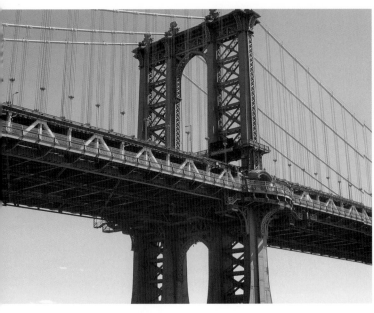

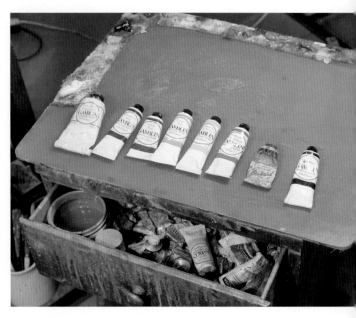

1 ⚙ Select an image

First, pick a photo to work from that contains an aspect that would be fun to paint, such as reflections on water, or the massive feeling of an object within the scene. Then, use Photoshop to crop, adjust and compose the image to fit the aspect ratio of your panel, to make the laying in and adjusting the drawing much easier. With this identically proportioned reference image, you can more easily decide if your drawing is correct.

"Pick a photo that contains an aspect that would be fun to paint, such as reflections"

3 ⚙ Choose your brushes

Depending on the size of the panel, choose different sizes of brushes. Soft sable flats are ideal for loading up the oils' thickness on the panel and for dragging colour across a shape, and the bristles create texture within the paint strokes. Sable filberts are my favourite brushes for any kind of blending.

2 ⚙ Set up your palette

Arrange your palette to suit you. I use white the most, and then greens. The greens blend with blues, which I keep in the corner, and then to create cooler yellows I place those hues next to the blues. Beside the yellows I have a warmer red and then a cooler red. I hardly ever put browns on my palette, but it depends on the image. I often use black but I try to limit it, so I put it as far away from me as possible.

4 ⚙ Prepare your paints and media

Beside the ordinary odourless paint thinner to clean your brushes, make sure you have a puddle of Winsor & Newton Liquin Original nearby. The Liquin speeds up the oils' drying time and also adds a deeper wet look when the paint is dry. You can't use a lot of Liquin because it makes the mix too soupy, so it's a real balancing act. Also, Gamblin Flake White Replacement colour is great for its sticky texture and super opaque quality. It's also a very cool white – Titanium White has always been too warm and too transparent, in my opinion. Winsor & Newton Liquin Impasto Medium is great for adding body to your mixed colours.

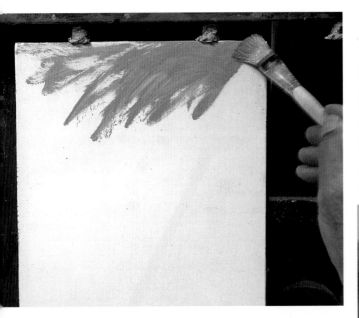

5 ● Prepare the panel

To calm the white of the panel, lay down an undertone by mixing a little warm colour such as an orange with white and black. Add a drop of Cobalt Drier to this mix (being careful not to get any on your skin, because it's toxic). Don't wait for it to dry, so when you start to sketch in the shapes and landmarks, your brush will pick up some of the drier and help to dry the sketch in place within 10 minutes. Always put down the faster-drying paint first. Adding faster-drying paint on top of slower-drying paint can create curdling, because the top layer is drying up on top of still-wet paint and will peel off if it's rubbed.

6 ● Sketch your lay-in

The lay-in sketch indicates shapes and acts like a blueprint. This drawing has to be solid, to save you from the frustration of having to make corrections later. To sketch it, take advantage of having your prepared image that is cropped to the same dimensions as your panel. Study and understand the lines within this reference. Are they horizontal? Vertical? Where is the most important line, the horizon? All of the lines of perspective need to meet somewhere on that horizon line, and understanding the perspective of every object will greatly affect the beauty of your design.

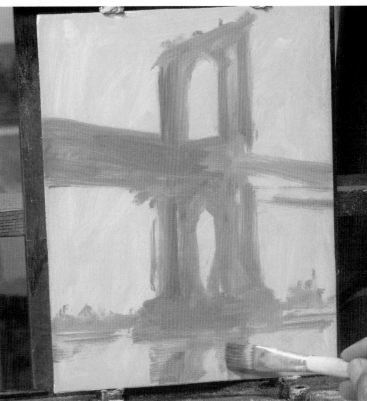

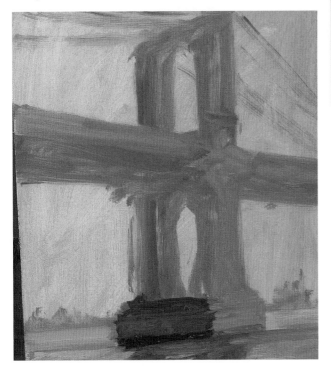

7 ● Place the darks and create structure

Placing each object with the correct structure in your composition is important. There are many elements in most scenes and you should strive to have a main focus, or what many artists call a centre of focus. This is the element that you want your viewer to see first. The most detailed structure should appear there. The other elements become support and are less detailed or have weaker value or colour so that the object of focus can be fully appreciated.

On the panel

Making my own wood panels is inexpensive compared to using canvas. They are a great surface to paint on for only about one dollar! I can experiment on them or throw them away if I don't like where the painting is going. I can throw paint more freely without worrying about the cost. My paintings have a fresher, more free feeling, which I like!

8 ● Establish values

Know where your darkest darks are, as well as your lightest lights. One way to make your centre of focus stand out more is to put your lightest tone right next to your darkest tone, to lead the viewers' eyes straight to that spot. Try not to have too many areas of high contrast in your compositions that may compete for attention, though. There are bound to be some, but there are also ways to lessen their impact (we'll look at these as we go). Besides wanting to emphasise your main objects, you also want to control the other areas so they support, but don't overwhelm, the elements you want the viewer to see first. Creating a value pattern that is less contrasting is important too.

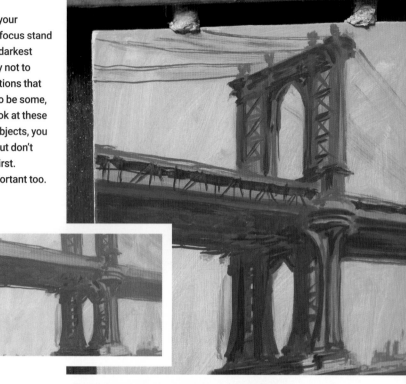

9 ● Simplify the scene

Don't depict the scene exactly as it appears in a photo or as if you are viewing it live. I can see detail everywhere, and it is sometimes hard to resist putting it all in. But it's editing out unnecessary detail, and instead painting the essence of the object and the key details only, that gives paintings their charm, mood and subtle beauty. John Singer Sargent could paint a subject's hand in a portrait in just seven brushstrokes. He didn't have to indicate knuckles, wrinkles or even fingernails to give you a beautiful and elegant hand, and as a viewer you didn't miss or want them. Don't paint details that distract or weaken the big picture.

Quick work

My oil painting is freer than my slick and detailed digital illustrations that form my daily work. I've promised myself that I will never work on a painting for more than a day. My illustration pieces take weeks, and I decided I wanted none of that in my oils. I love that my oil paintings, when viewed up close, are made up of globs and gashes of instinctively applied paint.

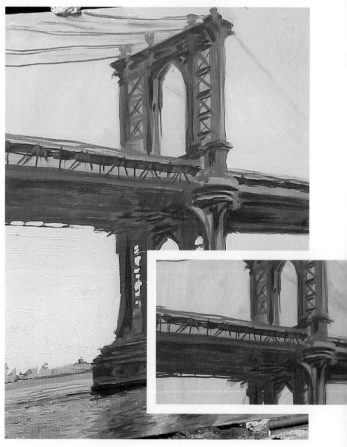

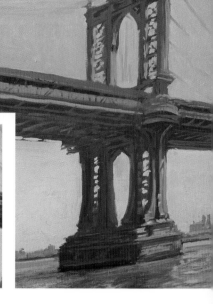

10 ◗ Develop colour harmony

They say if you get your values right, the colour doesn't really matter. It's true that this will ensure the subject of your image is recognisable, but it's the colour that sets the mood. You need to cover the whole panel to be able to analyse all the colours and values. Analysing your reference in minute detail is the key here. Know the direction of your light source and really seek out the bounce lighting and local colour of all the objects within your image.

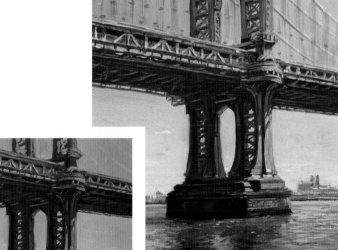

11 ◗ Build up paint thickness and textures

I like a lot of body in the final oil application, so don't thin the paint with turps in these later steps. Where you started with thin, fast-drying applications in the laying-in process, now finish off with thicker, slower-drying applications of paint. If everything goes perfectly, your darks should be close to what they were in the beginning, thin and fast-drying areas, and lighter areas should be heavy applications of stiff, thick colour.

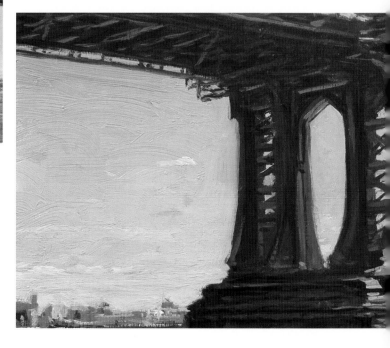

12 ◗ Finishing touches

In this final step, make any last-minute corrections and then go beyond the reference to brush in touches of colour or texture that will add interest to what could be a boring space or shape. You don't need to add detail as much as marks that may help it look like a painting instead of a straightforward depiction of the subject. This includes adding off-colour marks to the sky or bridge in places that don't distract but will add interest and break up the monotony of some areas.

Materials

- Italian Fabriano Hot Pressed watercolour paper (12x10in)
- Derwent graphite pencil HB
- Steadler Mars Lumigraph 4B
- Faber Castell pencils 4B and 6B
- Clutch pencil 2B
- Faber Castell putty eraser
- Derwent battery-operated eraser
- My go-to pencil grades are HB, 4B and 6B. These give me a variety of different tones and weights, varying with the brand.

Improve your pencil shading

Discover how **Melanie Phillips** uses a selection of pencils to draw a pencil portrait that captures a pet's unique personality on paper

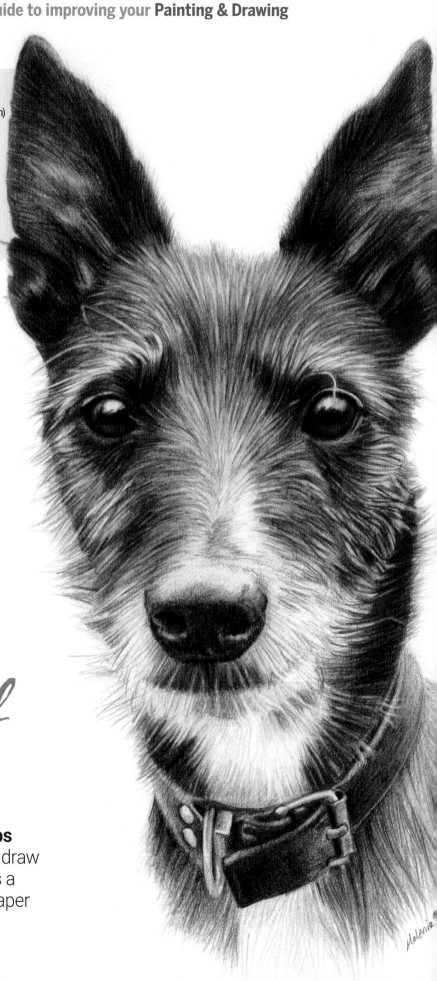

Poppy's owners asked me to draw a portrait, so that they can remember the happy times they spent with her. It's my job to not only create a drawing that's pleasing to the eye, but one that captures Poppy and not just any dog. That's the job of a pet portrait artist. Easy? Let's find out...

My favourite support is Italian Fabriano Hot Pressed watercolour paper. It always has been since I visited Italy in 1994. I had the opportunity to try out different Italian papers, including hand-made varieties. I found Fabriano to be a good smooth surface to draw on, and it's readily available here in the UK. My students have loved using it over the years. It holds lots of layers and can be forgiving if you need to erase areas.

I use a variety of pencils. In this drawing I have used three brands: Derwent, Steadler Mars Lumigraph and Faber Castell. These pencils are available from most art shops. For rubbing out, I favour Faber Castell's Putty eraser. I also use a Helix battery-operated pencil sharpener and it's brilliant. Who said drawing wasn't fun?

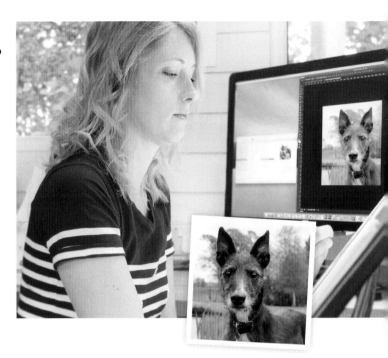

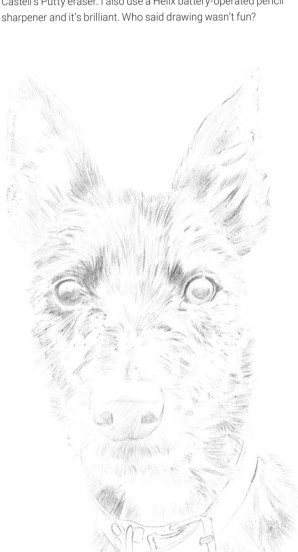

1 ◐ Get the drawing right

Artists use a variety of different techniques to achieve their initial drawing. These include using a grid method, sketching, tracing and projectors. However you get your initial drawing on paper, the key is to take your time and don't press too hard. I use a 2B clutch pencil. Make sure your outline drawing is correct before adding tone.

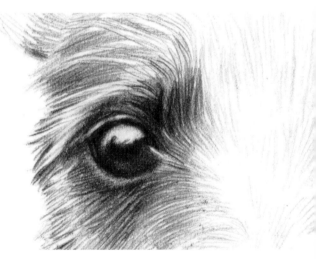

2 ◑ Straight in with tone

Once I'm happy with my initial drawing, I start with detail and tone. I'm using a 4B Faber Castell pencil. It's possible to work across the entire portrait at once and build up, or to work on single areas at a time. I take the latter approach in this portrait – I prefer to start with the eyes to bring the dog alive from the outset.

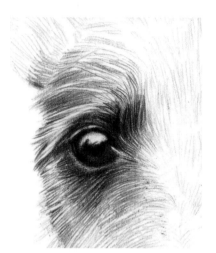

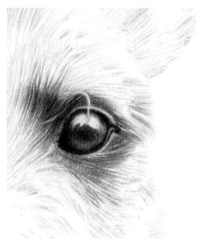

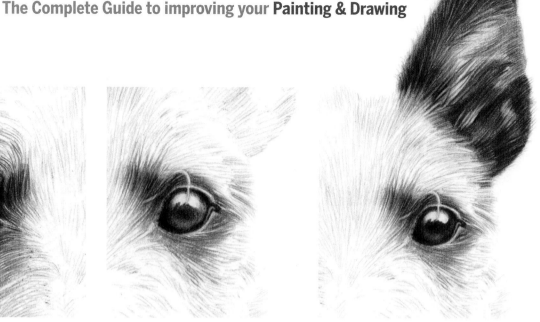

3 ⬥ Get the eyes right

The eyes are key, because it's the first place that anyone will look. They must have the illusion of being shiny and alive, and so it's imperative to take your time in this area. I try to look at my reference photo and then back to my drawing constantly as I work. I also leave the white of the paper for highlights and white fur.

4 ⬥ Build out

I'm not worried about the eyes being finished because I can work back across the entire portrait as I go. I start to build out from the eyes into the fur, still using the 4B. I shade the negative spaces and leave the fur as the white of the paper. I then shade over lightly, knocking back areas that are overbright and stand out too much.

5 ⬥ Move on to the ears

The ears are great fun to shade, as I'm dealing with a different texture to the rest of her. They're smooth with a few light hairs on top. I'm paying attention to the direction I shade in, to match the undulations of her ears. I tend to work outwards, beginning nearest the head and shading out to the tips of the ears.

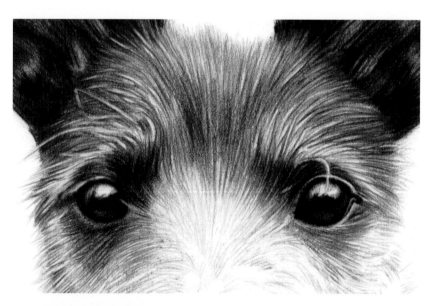

6 ⬥ Slowly build up

I'm slowly building up my layers, starting to employ the 6B Faber Castell pencil, too. This helps to achieve some darker tones. I don't need the ears to be completely finished at this stage; I can check back once the main part of Poppy's face is in. I can then judge how much darker they need to be.

Back to basics

Draw from life whenever you can. My art teacher told me never to work from a photo, which is ironic as that's the basis of my job. He meant however, learn to draw from life too because it'll teach you the fundamentals.

7 ⬥ Tackle fur!

I'm taking the time to build up my layers gradually on the top of Poppy's head. I use my 4B Faber Castell pencil, keeping it sharp. I work in the direction of the fur, shading the darker areas in between the lighter flecks. I use my putty eraser moulded to a point, to lift off any unwanted tones.

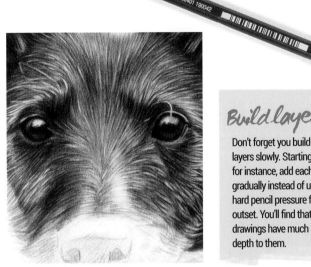

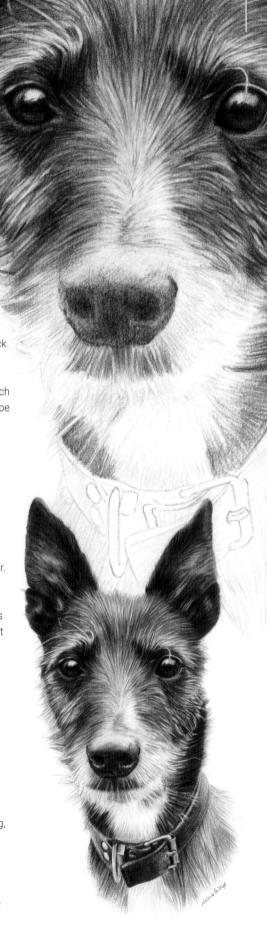

Build layers

Don't forget you build up your layers slowly. Starting with a 4B for instance, add each layer gradually instead of using a hard pencil pressure from the outset. You'll find that your drawings have much more depth to them.

8 ◐ Shade Poppy's face

I continue the same kind of fur texture as I work through Poppy's face. With more surface area filled, I realise more tone needs to be added across Poppy's forehead and ears. I work back into those areas with a Faber Castell 6B and the Steadler Mars Lumigraph 4B. The Lumigraph creates a darker tone. Keep your pencils sharp!

9 ◐ Work on her nose

Starting on Poppy's wet nose I block the entire area in at once. I'm using less pencil pressure with my 4B Faber Castell pencil. Poppy's muzzle is very much lighter in tone. To convey the delicate shape of her mouth area, I shade between the white hairs on her upper lip. If I cover too many I use my putty eraser to bring them back.

10 ◐ Bring it all together

Using my 4B Steadler Mars Lumigraph I start to add some darker tones into the nose, nostrils and darker fur. I'm balancing tones across Poppy's face and ears at this point, making sure the tones work overall. I soften the transitions and shading over areas using my Derwent HB pencil to pull everything together.

11 ◐ Know when to put down the pencil

I take my time shading the collar to make sure it's correctly drawn noting the highlights and shadows.
It's essential to keep my pencil sharp. I keep my fur tones fairly light as I move down the chest to the edge of the drawing, so that it fades off nicely. Knowing when you are finished with a portrait is tricky. Stand back, look at it with fresh eyes and compare it with your photo. If you feel you've captured the dog in your reference photo, then you've achieved your goal. I hope you feel that I've captured Poppy!

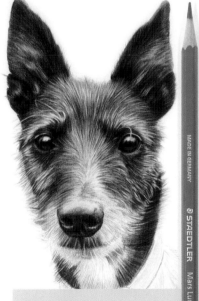

To the point

Keep your pencils sharp! I've found that the safest and fastest way to sharpen a pencil is by using a rotary pencil sharpener – a great piece of kit and fun to use!

Materials

Margaret uses tubes of **Schmincke** watercolour paints. She likes to paint on **Arches 300gsm paper**, approximately 11x15in with a fine surface stretched on to a board. This is her preferred paper because the surface has just the right amount of resistance to enhance the inherent transparency and brilliance of the medium. Margaret uses **synthetic round brushes**.

Simplify painting with a strong composition

Margaret Merry demonstrates how to use watercolour to capture the charm of a summer garden, with its ephemeral light, shade and colour

Since ancient times, gardens have been a source of inspiration for artists. However, they can be tricky subjects to tackle because, when the eye is confronted by a confusing array of tone, form and colour, it's difficult to know where to begin. The answer is good composition, and the best way to compose a garden painting is to find a point of focus, such as an ornament, a chair or a fountain. Old, weathered walls are a favourite of mine. For my demonstration, I chose this quirky, painted sewing machine table, set against the plain background of a white wall. The dappled light shining through the trees cast interesting shadows.

For all my work, I use a limited palette comprising: Ultramarine Blue; Cobalt Blue; Yellow Ochre; Raw Sienna; Burnt Sienna; Burnt Umber; Lemon Yellow; Alizarin Crimson; Cadmium Red. However, when painting flowers or similarly colourful subjects, it's useful to have one or two extra pigments, such as the Brilliant Opera Rose and Cobalt Turquoise I've used in my painting. Transparent pigments, not opaque ones, are best for painting flowers.

Light is an important consideration when painting gardens because it is constantly changing. I painted this watercolour in strong, afternoon light, shaded by trees. For a more romantic effect, early morning is the best time because all the colours are softened.

Green is the predominant colour in a garden and to maintain colour harmony, I always mix my own greens using my basic pigments.

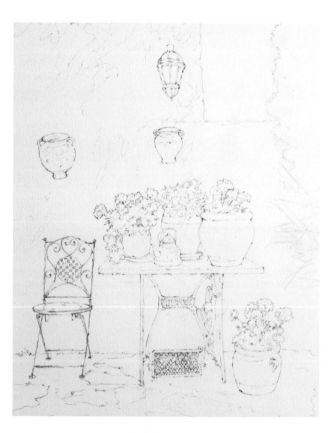

1 ◐ Do a preliminary drawing

With well-sharpened 2B pencils, I make a fairly detailed drawing of the composition, altering things I don't like, such as the position of the chair. I have included the cypress tree on the right and a few fronds of palm leaves because I like the sense of enclosure they create. Use soft strokes for drawing and don't be tempted to use an eraser because this will mar the surface of the paper.

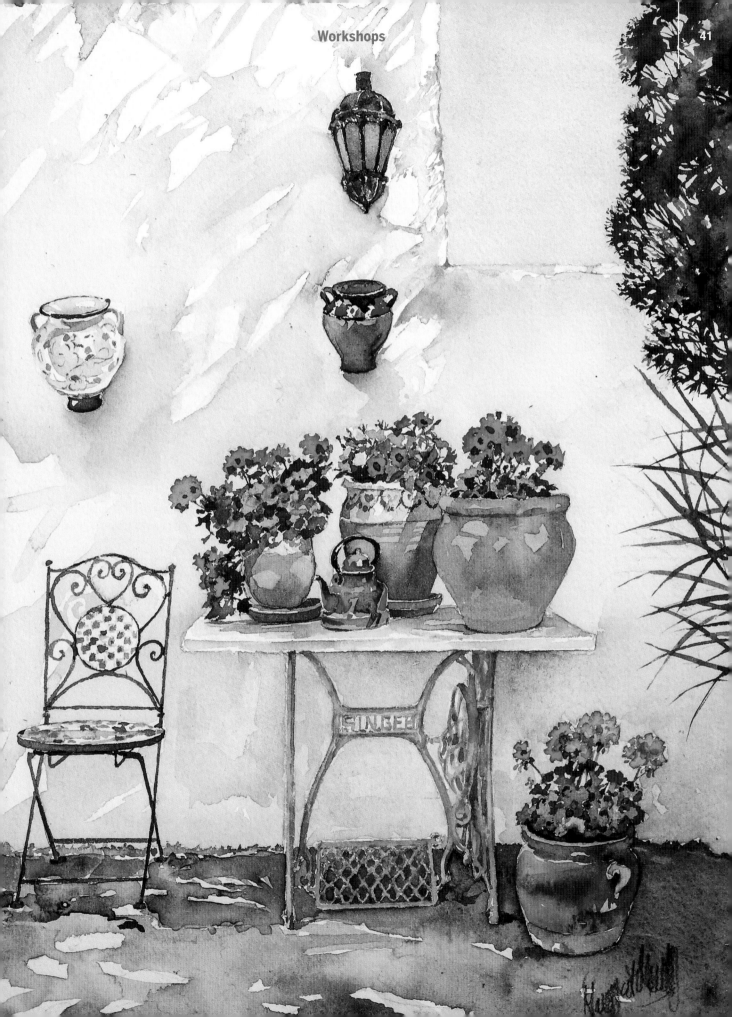

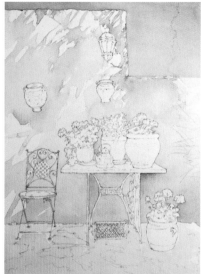

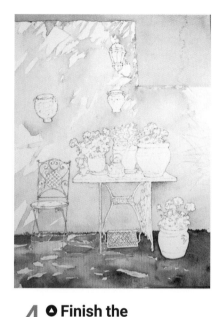

2 ⬤ Begin painting

I apply a transparent wash of Cobalt Blue for the sky, using a synthetic size 12 brush, extending it over the tree. With a mix of Cobalt Blue, Yellow Ochre and Rose Madder, I paint the shadows in quick, bold strokes, softening hard lines with the brush loaded with clean water. I allow the water to separate the pigments to prevent the background from being too uniform.

3 ⬤ Continue to apply background shadows

I continue painting the shadowed areas with my Cobalt mix and with a smaller synthetic brush (size 6) I carefully work around all the various objects so that the paper remains white. I paint rapidly because I want to finish this stage before the pigments dry. Lastly, I lay a transparent wash of Raw Sienna on the ground.

4 ⬤ Finish the background

When the Raw Sienna has dried, over-paint it with a mix of Ultramarine Blue, Raw Sienna and Alizarin Crimson. While the paper is still wet, allow some touches of Burnt Sienna to flow into the grey, giving warmth to the foreground. Again, I let the pigments separate and I use my size 2 brush to quickly draw around the various objects before the paint dries.

5 ⬤ Draw with the brush

Now that all the unnecessary white has been eliminated, I can begin working on the main feature: the sewing machine table. This involves detail, so I continue using my size 2 brush, which has a fine point yet is large enough to hold a reasonable amount of water. I use Cobalt Blue with a touch of Cobalt Turquoise and I vary the tones by diluting the lighter parts with water.

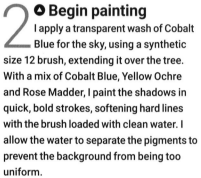

Know your tools

When I first began to paint with watercolour, I used it mainly to lay flat washes over pen and ink drawings or pencil sketches. In this way, I familiarised myself with the medium and developed my technique from there.

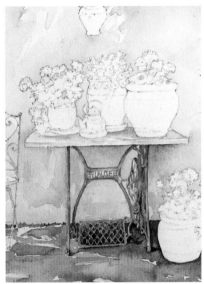

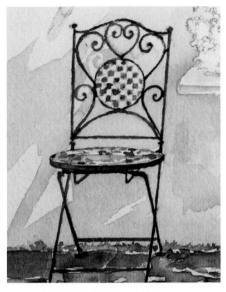

“I never use black pigment because it contaminates other pigments”

6 ⊙ Add more detail

Now that the table has been painted, it looks as though it's floating, so more shadow is needed. I use my dark grey Ultramarine mixture to paint around and below the table and add more definition where the blue tends to merge into the background. The marble top is painted with a very diluted grey and I add some dabs of Yellow Ochre to the wet paint.

7 ⊙ Draw with a fine brush

The little metalwork chair is relatively simple to paint as it involves mostly drawing. For this I use my finest synthetic brush, size 0. The chair is painted black but I never use black pigment because it contaminates other pigments. I mix, as an alternative, Ultramarine Blue with Burnt Umber. I use less water than before and with a steady hand, draw the details. With the Ultramarine grey mix, I add more shadow around and below the chair.

8 ⊙ Paint the flowerpots and lamp

I return to my size 2 brush to paint the lamp and the flowerpots on the wall. In order to avoid overworking them, I use plenty of clean water to soften the outlines and give just an impression of detail. I introduce more colour by adding Burnt Sienna and Cadmium Orange for the terracotta pot and the lamp, and Cadmium Red for the decoration on the ceramic pot. I paint the shadows on the pots with a watery grey, using circular brushstrokes for a rounded effect.

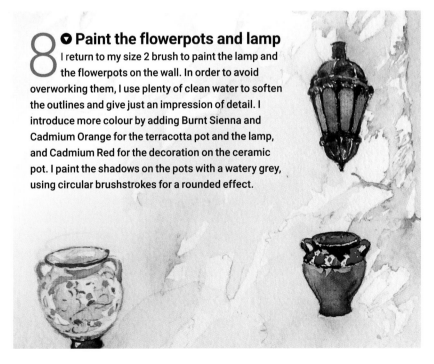

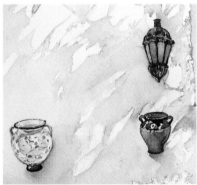

9 ⊙ Embed with shadows

As was initially the case with the table, the lamp and the pots look as though they're floating. This is fixed by adding shadows around and underneath them. For this, I use the subtle Cobalt Blue mix with which I began painting the background. Again, I soften some of the hard lines with a brush loaded with clean water.

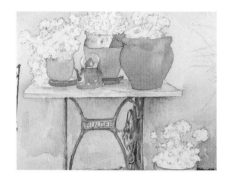

10 ◗ Work on the terracotta pots

My method for tackling terracotta flowerpots is to paint a transparent base coat using Cadmium Orange, Burnt Sienna and Raw Sienna. The shiny kettle has a transparent coat of Cadmium Red and where the light falls, I've left white patches. Before I continue with the second stage, I make sure the base coat is completely dry.

Speed painting

Watercolour is a medium best suited to rapid, spontaneous painting. I find that if I spend too long on a work, inspiration wanes and I'm invariably dissatisfied with the result.

11 ◗ Create form

To create form, I paint a second coat using my Ultramarine mix and, as before, my brushstrokes are curved to follow the shape of the pots. I like the patterns cast by the shadows and so I make a feature of these, but still keeping the paint very fluid to maintain transparency. I apply the same technique to the red kettle and finish by painting the decoration on the pots.

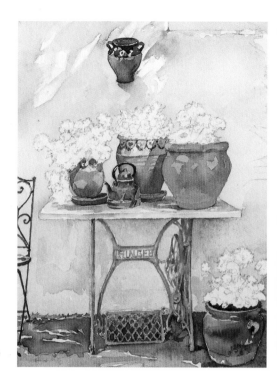

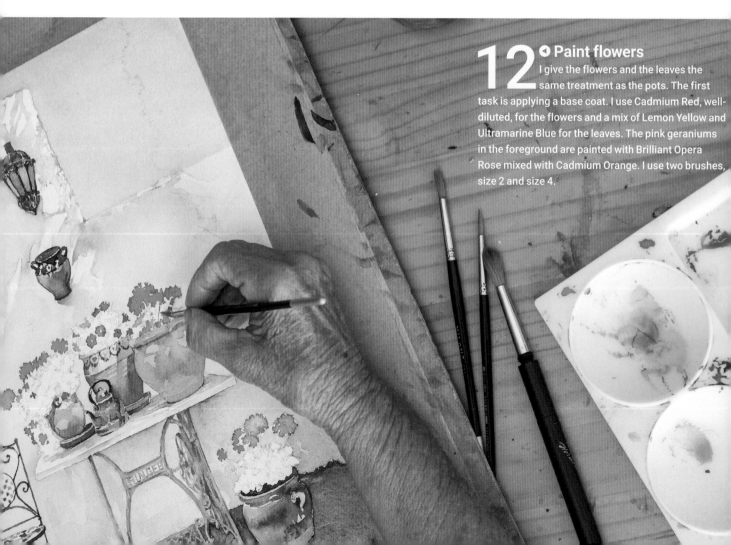

12 ◗ Paint flowers

I give the flowers and the leaves the same treatment as the pots. The first task is applying a base coat. I use Cadmium Red, well-diluted, for the flowers and a mix of Lemon Yellow and Ultramarine Blue for the leaves. The pink geraniums in the foreground are painted with Brilliant Opera Rose mixed with Cadmium Orange. I use two brushes, size 2 and size 4.

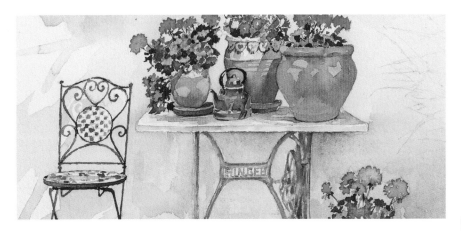

13 ○ Add definition

I begin with the leaves, adding a touch of Raw Sienna to the green mixture to make it darker. I have to take care not to paint too much detail, but, at the same time, I want to make a feature of the leaves. Knowing what to paint and what to leave out comes with experience! Again, the hard lines are softened with water and it's the latter, rather than the brush, which works to blend the greens into each other.

14 ○ Finish the flowers

I paint the darker tones on the flowers as I did with the leaves, using just a hint of Ultramarine to define the shaded parts. When painting flowers, it can be very easy to lose the freshness and transparency of the medium if they are overworked and for this reason, I keep the pigments as pure as possible, bearing in mind that it is difficult to rectify mistakes when painting flowers in watercolour.

15 ○ Complete it

As the painting nears completion, it's time to paint the cypress tree and the palm fronds to form a frame. For these, I use my basic green mixture (Ultramarine Blue and Lemon Yellow) darkened with Raw Sienna and Burnt Sienna. For the lightest areas, I drop pure Lemon Yellow into the wet paint and with a fine brush, I draw the pointed leaves, from base to tip, using a flicking movement. A few last touches of shadow complete the painting.

Materials

"Oils are extremely receptive: easy to rub off, easy to blend, and great for subtle work."

- Four oil colours: Cadmium Red, Titanium White, Yellow Ochre and Lamp Black
- System 3 acrylic paint in Raw Sienna
- Stretched and primed 18x 22in canvas
- Large decorator's brush for ground
- Daler Rowney Georgian Oil Brushes
- Winsor & Newton Liquin™ Original
- Transparent plastic/glass palette, with paper painted the colour of the ground underneath
- Palette knife
- White spirit (or turpentine) and rags

Create a self-portrait with just four colours

BBC One's 'The Big Painting Challenge' finalist **Claire Parker** guides you through capturing your own likeness in oils using a limited palette

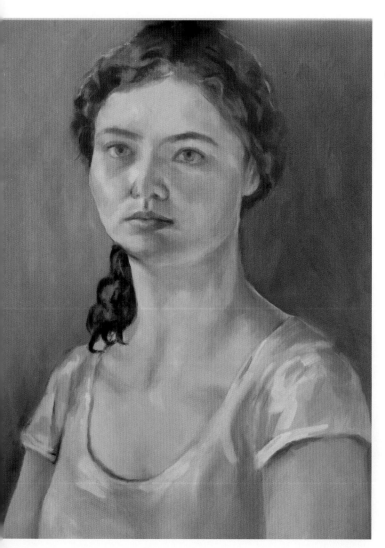

S elf-portraiture is one of the most rewarding challenges an artist can attempt. Because we know the landscapes of our own faces better that anyone else, we know when the painting looks right. While self-portraiture can be a way of projecting a certain image of yourself onto a canvas, it can also be a process of self-discovery.

Capturing a likeness takes practice, but the trick is not to get frustrated. I don't tend to use drawing aids such as a projector or grid (though these can be useful). I like the process to feel organic, and making mistakes is part of that.

Here, I'll be using a palette of Lamp Black, Titanium White, Yellow Ochre, and Cadmium Red. It's surprising how great a range of tones can be created with just four colours and a limited palette often creates a subtle, harmonious portrait.

To set up, position a mirror on a table or wall so that you can easily glance between the canvas and your reflection. Make sure your workspace has plenty of natural light – if the light hits one side of your face and casts the other in shadow, it will help you find form.

◉ Set up your canvas and palette

I've painted a thin Raw Sienna ground to add warmth to the work. I'm using a transparent palette and have put painted paper of a similar colour to the Sienna ground underneath it, so I know what the colours will look like on the canvas as I'm mixing them

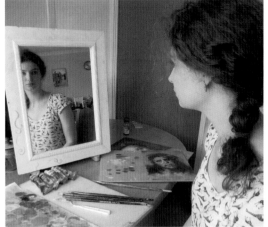

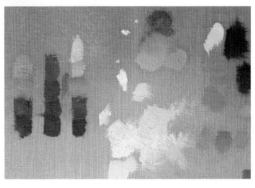

1 ◉ Draw it out

Using a thin mix of Cadmium Red and Yellow Ochre, I start drawing what I see in the mirror. At this point, I'm trying to capture the basic movement of the figure, as well as the angles where the head meets the neck and torso. I build up the sketch, using expressive strokes to mark out the areas of light and dark, and use these areas to find the eyes, nose, and mouth. A likeness isn't important at this stage – you just need to see how the portrait will take shape when you begin to add colour.

2 ◉ Test your colours

Before adding colour, I explore the range and qualities of the four colours I've chosen. On a separate canvas, I try out different combinations in a grid, as well as mix a few skin tones to see what the effect is.

3 ◉ Block in

Adding the first blocks of colour really breathes life into a portrait. Using the red, yellow and white, I mix a light, mid and darker skin tone. Using these mixes I roughly block in the colours using my tonal sketch as a guide. Keep looking in the mirror and be receptive to changes and discoveries.

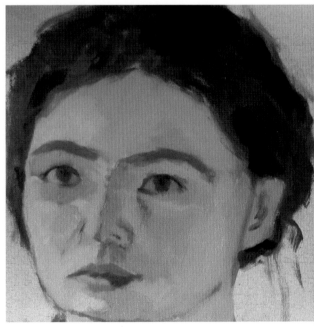

4 ◉ Work on lips, hair and eyes

I mix light, mid and dark tones for the hair and the lips. For both, I'm using proportions of red, black and white. To paint hair, keep it light and suggestive without painting heavy blocks of colour or tiny individual strands. My eyes are blue-green, but there's no blue or green in my palette. However, a mix of black and white creates a blue grey. I've added a small amount of Yellow Ochre to the grey to create a greenish hue. I mix an off-white for the whites of the eyes.

5 ⊙ Deepen and darken

Now that I've added the dark hair, the balance of tones in my painting has changed, and suddenly my face looks pale, even where it is in shadow. To restore the balance, I'm darkening the shadows on the right side of my face, using tones similar to those in the hair. I've also started trying out a colour for the background to see how it looks against the skin tones.

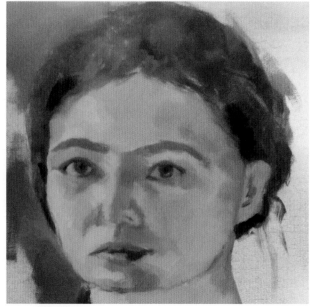

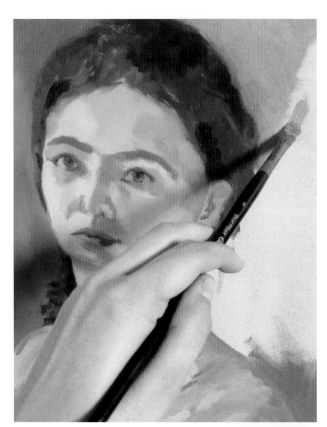

6 ⊙ Start on the background

You need the background colour to set off the foreground without upstaging it. I've decided on a warmish brown, which I want to pick up some of the purple and orange tones in the face. Once I've chosen the colour, I start picking it up in the right-hand side of the face and neck, which helps make the shadows recede, bringing them closer to the background.

7 ⊙ Colour the clothing

I am wearing a white top but, as with the whites of the eyes, I don't want to use pure white to block it in. Instead, I use all my colours to create a warm grey, which I block in with three tones. I can now add establish lights and darks on the neck, and bring out some of the more yellow tones.

Quick pic

This masterclass is the first self-portrait I have attempted since the one I did on *The Big Painting Challenge* (above). We were only given three hours and there was bucketloads of pressure, and I can see the stress and panic I felt all over my portrait!

Great idea!

Avoid black-and-white thinking. Even when adding the darkest darks or lightest lights, I never use pure black or white – it saps the colour out of a painting in an instant.

9 ❍ Nip and tuck

As I've been working, I have inadvertently thinned the neck, lowered the left shoulder and lowered the chin. My left eye is also too high up and needs repositioning. As you make tweaks, don't worry if you lose the likeness at this stage.

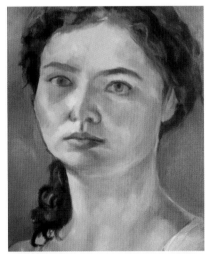

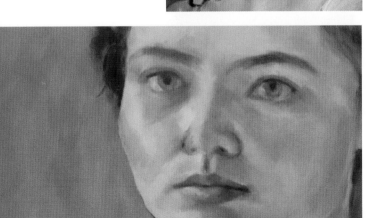

8 ❍ Work on the detail

I pay attention to where the shadows might be more blue or yellow, and to where the highlights fall on the face, defining the features. I add warm, orangey tones around the eyelids. Here, I take a lighter touch with my brush, and blend the colours carefully without losing the individuality of each stroke.

10 ❍ Highlight

Using a small round-tipped brush, I add some highlights where the light hits my hair – again, not pure white, but a very light ochre. Don't be afraid to use thicker paint.

11 ❍ Soften up

I am getting close to finishing, and don't want to overdo the painting. I start to add thin layers of paint to areas of dry canvas, which helps to soften, unify, and add finish to the painting. I'm creating the layers by adding plenty of Liquin to my paint until the mix is almost transparent. This technique also works well for the background, deepening its texture without making it distracting.

12 ❍ Sleep on it

When I went away from the portrait and came back to it in the morning, it became clear what wasn't quite right. So, I thicken the hair, raise the right shoulder, change the direction of the gaze, and darken the eyebrows, hair, and neck. I've also added some small curls of hair. Small details can make all the difference.

Use a light touch for spontaneous results

Margaret Merry demonstrates the versatility of pastels and the medium's ability to capture the ever-changing nature of a seascape

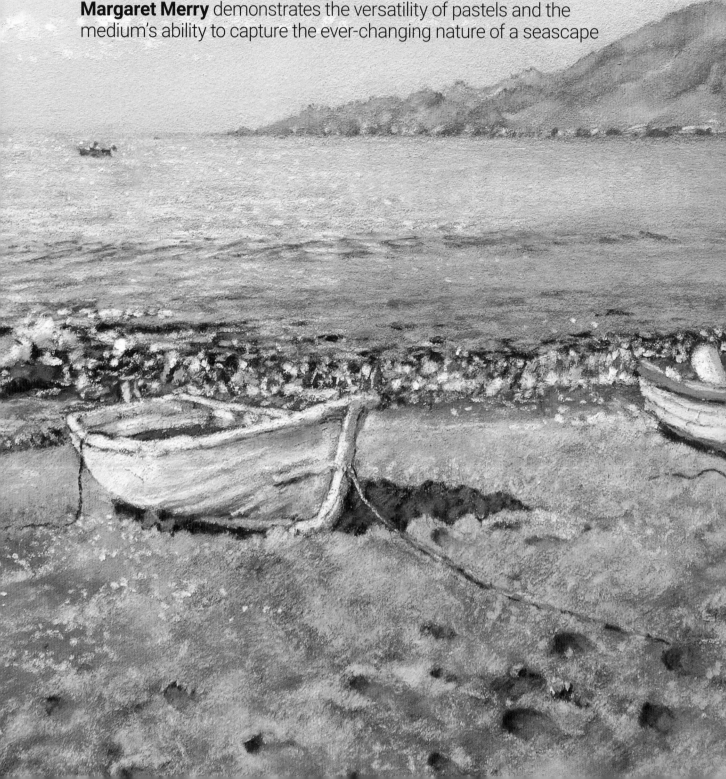

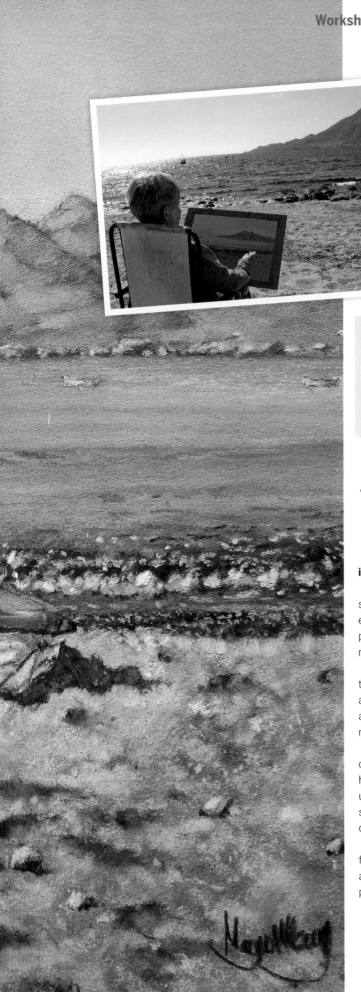

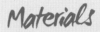

Materials

For this workshop I use Sennelier Pastel card (360gm), measuring 50x32cm, Naples Yellow and Unison and Sennelier pastels. The pastel card has an abrasive surface over which the pastels glide easily, and I appreciate their superb softness and good colour range. For drawing detail I use Derwent pastel pencils.

T hrough this workshop, I hope to convey my enthusiasm for the ancient medium of pastels and inspire readers who might feel a little daunted by it. The wonderful range of colours available to artists is in itself an inspiration: all that's needed is a suitable subject to paint (nothing too intricate or detailed, mind) and a little confidence.

Before beginning a painting, I spend some time studying my subject and imagine myself going through all the stages of its execution. Only by this mental process can I feel confident that my painting will be successful. If I can't visualise the finished product in my head, then I know there's no point in beginning the project.

I chose this particular scene because I liked the composition with the distant volcanic peaks and the boats for foreground interest. I also liked the effect of early morning sunlight sparkling on the water and the crisp, white waves breaking on the shore. These factors make the subject ideal for a pastels painting.

I selected a range of blues and some warm colours to complement them. It's important to bear in mind the overall colour harmony when selecting the pastels. For my pastel work, I always use Sennelier pastel card and prefer a neutral tone for most subjects. This ensures that the colours of the pastels aren't distorted and, where the paper shows through, it isn't obtrusive.

Pastel is a rapid medium to work in, and because it's not suitable for detailed pieces, it enables the artist to be more spontaneous. It also encourages a looser approach – something that those new to pastels often find difficult.

1 ○ Sketch the preliminary drawing

I use a soft pencil (2B) to sketch the scene, making sure that the horizon is well above the centre of the paper, in accordance with the basic rules of composition. I place the boats in a similar manner, off-centre, to balance the composition. The slight diagonal of the breaking waves contrasts nicely with the horizontals.

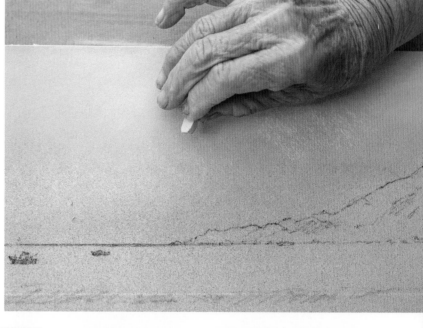

2 ○ Paint the sky

I began with the sky because it's best to work from top to bottom when using pastels – you'll avoid dragging sleeves and other items of clothing across the paper. Before applying a pale tint of cerulean blue, I put down a base of pale tangerine, using broad strokes. Over this, I rub in the blue to develop a smooth finish and allow the warm tangerine tint to show through on the horizon. I want a lighter effect on the left, where the sun is shining, and darker blue on the right.

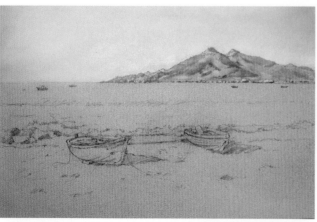

3 ○ Work on the middle ground

With the sky established for the time being, I begin working on the mountains, using warm colours combined with cool shades of violet-grey to determine the light and dark areas. I sketch in the most prominent lines with a burnt Sienna pastel pencil, and add some touches of green on the lower slopes.

Try them first

Artists' quality pastels are expensive. Before investing in a range of colours, I'd advise experimenting with a single pastel – the palest tint of yellow ochre, for example – by using it to highlight a charcoal or charcoal pencil drawing. This will help you gain a feel for the medium.

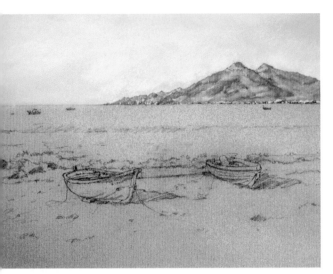

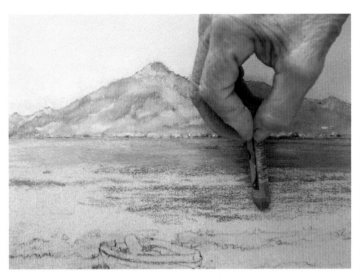

4 ● Develop distant perspective

Having established the basic shapes and forms of the mountains, I need to soften the hard lines and strong colours by overpainting with a very cool, lilac tint, using the pastel on its side and taking care not to pick up any underlying pigment. This unifies the whole composition and helps to create a sense of distance and perspective.

5 ● Focus on the sea

Now I can begin working on the most challenging part of the painting: the sea. I lay a base of pale blue, graduating to a darker blue on the right. Having established this preliminary stage, I now need to create an even darker blue, with undertones of red, below the mountains. So I paint a base of dark violet, using the point of the pastel to make broad strokes. On top of this, I rub in a medium blue.

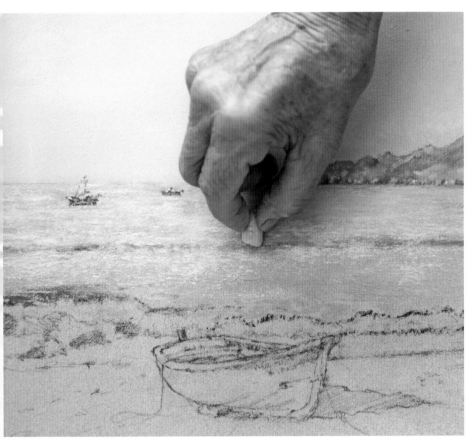

6 ● Capture the sunlight

I'm happy with the blue tones, over which I can continue working on the sea, so I'm concentrating on the more interesting part: the effects of movement and sparkling sunlight. For the sunlight, I use the lightest shade of yellow ochre together with a pale, pinkish-white, employing the same finishing technique I used for the mountains, with the pastel on its side. A very light touch is required here and it's important to avoid overworking. I also sketch in the distant boats.

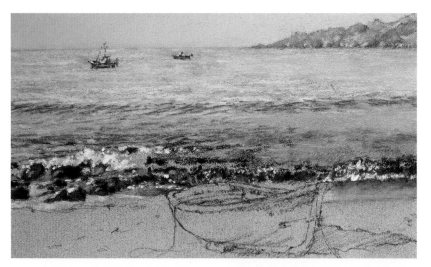

7 ◉ Illustrate the gentle movement of the waves

In this step, to indicate the waves as they approach the foreground, I apply a dark blue and blend it into the base colour. To create a sense of texture, I crosshatch lines in an even darker blue over the waves and highlight them with a pinkish-white pastel. I add a warm tint to the sea on the right to give the impression of the mountains that are reflected in the water. I paint the rocks on the shoreline using tints of brown, grey and Raw Sienna and a base layer of the same colour underneath the breaking diagonal wave.

8 ▶ Develop the shoreline

I paint the white foam above the dark underside of the breaking wave. I never use pure white; instead, I prepare a selection of warm and cool, very light tints that serve as white. A medium mauve-grey creates the parts of the foam in shadow and I use a warm brown for the reflections in the wet sand. Now that I've completed the sea, I add the finishing touches of sparkling sunlight by dotting little marks, using the tip of a yellow-white pastel stick.

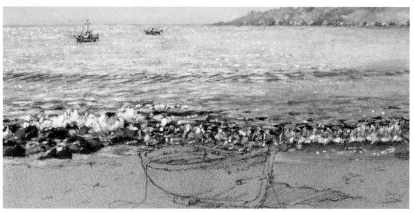

9 ◉ Work on the foreground

I'm happy with how the horizon and middle distance are looking, so now I tackle the foreground. Using a warm brown and shades of Burnt Sienna, I apply broad strokes to make a dark base for the lighter colours I intend to overlay later. One of the hazards of pastel painting is dust and it's at this point that I sneeze and make a mark on the paper! I have to disguise this by painting in a few clouds.

Why pastels?

Pastel is a rapid medium that's ideal for capturing atmospheric effects, such as misty mornings, or moving subjects like animals and children. Because it's applied with the fingers, the artist has more control than with a brush and there's the added, tactile pleasure of the pastel stick crumbling against the paper. The fact that no other tools are required makes it an ideal medium for working outdoors.

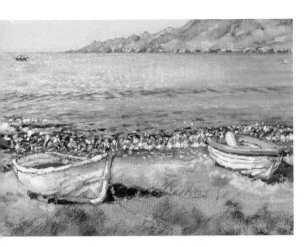

10 ◐ Illustrate the boats

I'm keen not to introduce too much detail when it comes to painting the boats, and so I apply the pastel in thick, rapid strokes, softening any hard lines. The shadows under the boats are painted in dark brown overlaid with a dark blue-grey. The orange around the upper edge of the smaller boat generates visual interest in the foreground and complements the blue.

11 ◐ Add texture

To contrast with the smoothness of the sea and sky, I need to create plenty of texture in the foreground. I achieve this by applying thick layers of pastel in warm, pale tints and use warm browns and greys for the shadows in the sand. Because I'm working on an abrasive paper, the thick layers of pastel adhere well – a key factor when employing this technique.

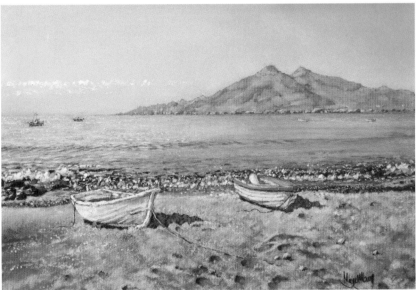

12 ◐ Finish up

Now that most of the work is done I can concentrate on the finishing touches, such as the stones in the foreground and the ropes attached to the boats that help to draw the eye into the picture. I add a few more highlights here and there and soften any lines that appear too hard. Finally, I give the paper a good thump to remove any loose pastel dust.

Preserving pastels

I dislike the use of fixative because it spoils the natural bloom of pastel. In addition, I've found that, over a period of time, the humidity in the air helps pastel work to fix itself. I prefer to protect my paintings by mounting them on to a lightweight foam board, secured with adhesive mounting corners, and putting them into plastic sleeves where they remain until they're framed. Using this method, I have sent pastels by post all over the world.

Tips to paint vibrant water

Jennifer Branch shows you the secrets behind painting energised water and realistic reflections in any situation

Painting water can sometimes seem overwhelming. Water moves constantly, so capturing a moment without the aid of a camera may appear impossible. But paintings can convey the constant movement of water in a way that photos struggle to, as long as you have a good water-painting technique that ensures your pictures are as full of life as the real thing.

The following top ten tips explain a few basic skills and techniques you can use to paint water that looks spontaneous and vibrant. Although I use watercolours, these tips also translate to the medium of your choice. Practise en plein air whenever you can, but you can work from photos when you need to.

You can't paint the same water twice, since it's ever-changing. Capturing the energy in that movement is what makes water so amazing to paint. I love to sit by a lake or the ocean and paint at different times throughout the day, using several sketchbooks to capture these fleeting scenes. One sketch dries while the others are in play. Take a photo before you start, so that if the light changes you can finish the last wash at home.

Water can be opaque, transparent, choppy or smooth, but you use the same techniques for painting it. Follow these tips to make sure that all of your water paintings are vibrant and lively.

1 Paint still water first

Start practising when the water is calm and reflective, then later you'll be able to use the techniques you develop here to paint any other type of water, from raging surf to a rippling pond surface. All of the wave and wind action makes the surf seem far more complicated to paint, but the principles are the same as for still water. If you learn to paint reflections and subtle ripples on that calm pond, a crashing wave at the beach will be easy to paint. A wave is just a very big ripple, after all.

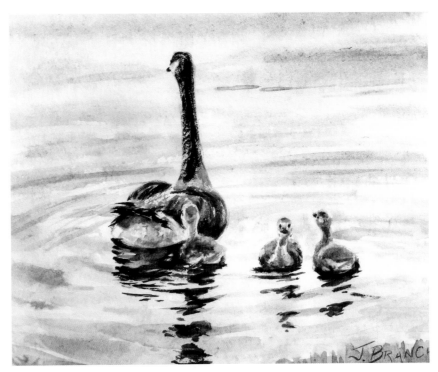

3 Notice colours

Water is only blue if it's reflecting blue! Look at the colours in the reflected trees, sky and objects and use these colours as your palette for any water that's not white foam. Even the hull of a boat or sky not seen in your painting might still be seen in a reflection. To connect the water and landscape, pull the colours from the reflected objects directly into the water reflection, then go back and sharpen the shoreline with a few strokes of strong darks.

4 Flatten distant water

Water appears flatter as it grows more distant, and horizontal lines can convey this flattening of the water's surface and the shortening of reflections. Use a few connecting horizontal dashes to show the distant water and reflections from the shore or objects on its surface. Streams and rivers also appear to flatten at a distance. Almost the same strokes you use for a reflected squiggle (as seen in the top right picture) can look like an entire river as it snakes away.

2 Reflect down

No matter what angle you're painting from, reflections always come directly towards you from the source. It's simple physics, but sometimes people may expect reflections to follow the same rules as shadows and perspective. To paint them, first pick a simple line in the reflected object such as a tree trunk or building façade. The reflection of that line will always be perpendicular to you, or the bottom of your page. This makes it easy to pull some pigment down from the reflected object into the reflection. All you need are a few dashes of movement on the next wash.

Make reflections dull

5 Light rays scatter on the surface of the water, so a reflection is never a perfect mirror. Therefore your palette of reflecting colours should be duller than the objects being reflected. Many artists continue their first wash from the objects into the water, then finish by adding duller washes with more movement on the surface of the water. Most bright whites in water are sunlight reflections. Darker colours usually look lighter in reflections and lighter colours darker. Add a touch of complementary colour to your pigment to get very close to the colour you need.

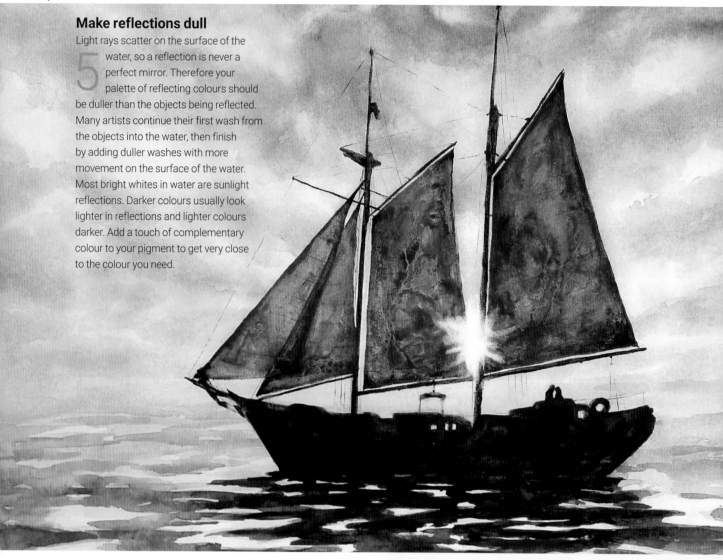

6 Paint pointed ovals for waves

The shape of a wave is an oval, curved in the middle with sharp points on both ends. Use a pointed round brush to paint waves. A flat brush gives you great broad strokes, but it fails you on the points. Start by painting one point of the oval with the tip of the brush, add more pressure for a broader stroke in the middle, then finish with the tip of the brush. The ovals can be evenly distributed or skewed depending on the wind and your perspective.

7 Know your light

Your light direction in a scene will tell you how dark or light the water looks. Backlit trees will be dark, but their reflection will be lighter. Conversely, bright front lighting will give you a darker reflection on the water. The light direction will also tell you whether the top or the bottom of the wave should glow with lovely Caribbean translucency. If the light comes through a wave at the right angle, the wave acts as a lens, focusing bright spots of light on the bottom.

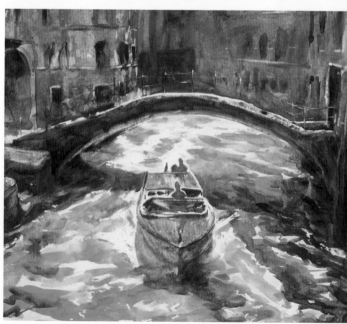

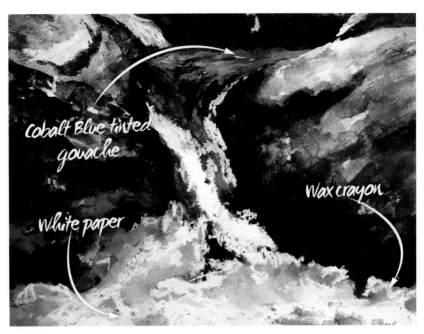

Cobalt Blue tinted gouache

White paper

Wax crayon

8 Paint in layers

Since crystal clear water, where we can see rocks on the bottom, is actually separate layers of water and rocks, the simplest way to paint these scenes is in layers. The key is to separate the different layers by letting them dry completely between washes. Don't be afraid to use strong dark colours in the first wash. Dry brushing gives you texture that shows up under the water. Paint the water in one bold wash, making wave-shaped strokes. Let your brush dance. You can use gouache for reflected sky or preserve the white paper with masking, wax or precise strokes (see next step).

9 Mix it up

Use a variety of techniques for capturing textured whites. I always like to leave more white paper than I use, as paper is the most sparkling white you have in your toolkit. It's easy to paint over whites, but you can never get the white paper back. However, don't limit yourself to just one shade of white. Permanent wax crayon preserves whites, while white or tinted gouache in a pale colour can give you highlights on the water surface. Lifting pigment softens edges. Wait until your painting is dry, then use a damp rag to pull out pigment.

10 Adjust texture

Hot press paper gives you rich colours and a smooth texture, which is ideal for painting water on a foggy day with no sparks of white reflection. You can use a lot of wet on wet brush strokes for blurred edges. Rough press paper gives you dull colours with reflected sparkles and texture, perfect for the seashore with white reflections, surf and rocks. Cold press paper falls between hot press and rough press, giving you a little texture and brighter colours, which is great for re-creating a peaceful pond scene with vibrant flowers reflecting.

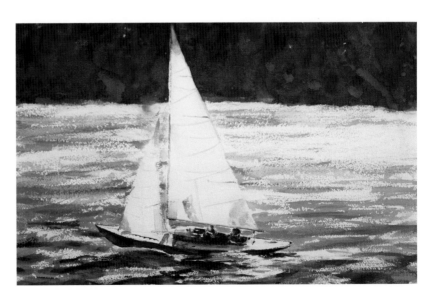

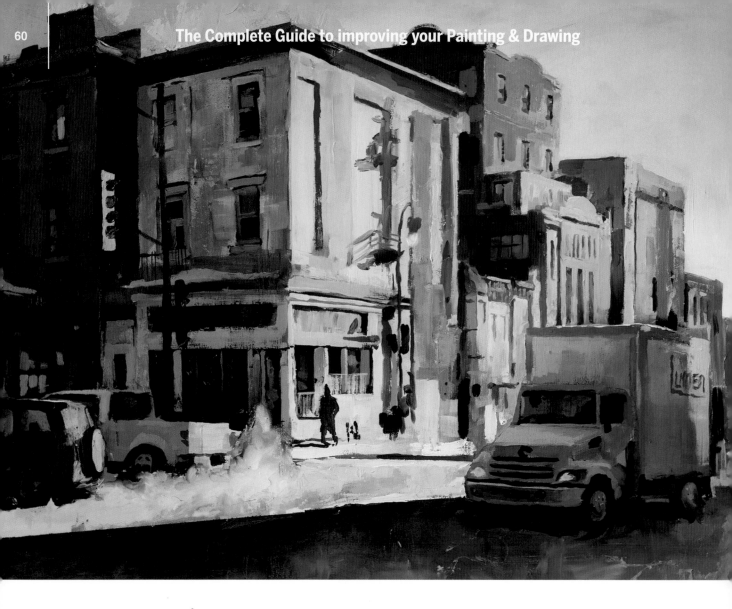

Depict a dynamic urban environment

Guillaume Menuel shows how he created a snapshot of urban life painted in oils in a loose, rough style

Before I began painting in a traditional way, I worked for years as a digital artist in the videogame industry. With that background, I felt the need to come back to something raw, something I could feel, smell and manipulate with my hands. Oil painting was a revelation, and I have been practising in this medium for almost two years now.

My favourite subject so far has been the city (Montreal by default). I've always been a city guy. I love how cities move, their dynamism, how everything evolves over time, the decrepitude and renewal tangling with each other, how it creates tons of shapes, colours and materials, depending on time of day or year. That's what I really enjoy painting!

Sometimes my subject is a wide landscape, or sometimes I focus on a street corner, as in this project. I'll show you how I paint in a spontaneous and loose way, working with layers of colours and never adding too much detail. The idea is to capture as much atmosphere and dynamism as possible.

Guillaume says this street corner has became a favourite subject of his, and he has painted it at various angles

Materials

Guillaume is using an 18x24-inch wood panel, gessoed and sanded smooth. To apply his oil paints, he uses a selection of flat, soft synthetic brushes, paper towels, painting knives and his fingers. His style of painting doesn't usually require high-level tools, and his brushes are relatively cheap.

1 Choose the right picture

My first step is as important as all the other ones – make sure you find the right reference! I take a lot of photos of Montreal, so I always have some good reference pictures in reserve if I need them. I like to choose something with a nice contrast. For this project, I chose a particular street corner I used to pass every morning on my way to work. I took the reference photo on a freezing winter morning and the light was absolutely fabulous.

2 Prepare the surface

I don't like to paint on traditional canvas, I prefer wood panels for their hard and smooth surface. You can buy wood panels at most art supply stores – they're not very expensive and are very solid. Before I lay down any brushstrokes, I prepare the surface to prevent the wood drinking up the paint. I apply two layers of a gesso (usually a white acrylic primer) and then roughly sand it when it's dry. That gives me a nice smooth surface to paint on.

3 Sketch the scene

For me, the sketching is the most important part. Now's the time to be sure my perspective and composition will work, to get everything in the right place. I don't add details at this point, just rough shapes and lines. Even if I'm working with a photo reference, I won't stick to it if something doesn't work – I feel free to move elements if I want to.

4 Find good tones

The dominant colours in this scene are deep blue for the shadows and a yellowish white for the highlighted parts – a nice winter-morning palette! To set the mood, I start with a very diluted glaze of Aquamarine Blue, turquoise and olive (olive is a nice choice to darken colours and keep them vibrant), which I mix with nut oil. The highlighted parts will be a mix of white, Naples Yellow and nut oil. The sky will be turquoise and white.

5 Create the mood

Time to have some fun! At this point, I'm using a very cheap large brush and paper towel. I apply my first lot of colour very roughly, spreading it a bit with the paper towel. I want to give a clear idea of the mood as soon as possible, and it's already taking shape. My approach doesn't need too much preparation and is really open to change and fluctuation.

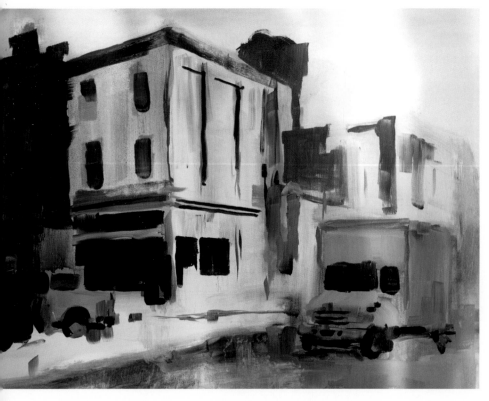

6 Shape the scene

After having this rough coloured composition, it's time to be a bit more precise and define what's what, shaping the vehicles, architecture and so on. I know that each brushstroke could be replaced by another one sooner or later, but I continue to make everything more clear for the next steps. My paint here is less diluted than the previous steps, as I want it to be more opaque.

"My approach doesn't need too much preparation and is really open to changes"

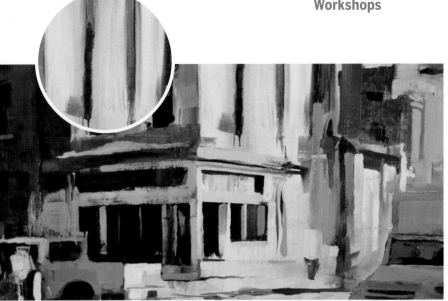

7 Add texture and depth of colour

I'm now making everything more precise, while still keeping it a bit sketchy. To get texture, I'm using very little paint on a small, flat, flexible brush, so I can see the strokes. This is really helpful for walls, for example. I pick my colours here and there off the palette, using some "mixing accidents" so I can add depth to my colours. This gives a nice range of shades.

8 Add in rough texture

To add some depth, I use my painting knife to paint in rough texture with undiluted paint, which I quickly apply here and there (mainly to the road and walls). The effect is built up quickly – it's very satisfying!

Art tip

I like to find a good tool to create some nice textures. Sometimes the tool can be as unexpected as a piece of cardboard directly taken from the breakfast cereal box that morning.

9 Get smoking

The exhaust smoke from the car in the foreground needs some more attention. Here I'm adding white paint on the right, and, with my finger, I've blended the edges to get that nice contrast of raw paint that blends to smooth edges. This is almost one of the only spots of the painting that deserves a more delicate treatment.

10 Add life with detail

It's only the key details that are missing now – and this will make a big difference and bring the last bits of life to the picture. The yellow traffic light, the car exhaust smoke, the walking man, the reflections in the windows. Here I'm using my smallest flat brush for the small details, and a bigger one for the finishing touches to the exhaust smoke.

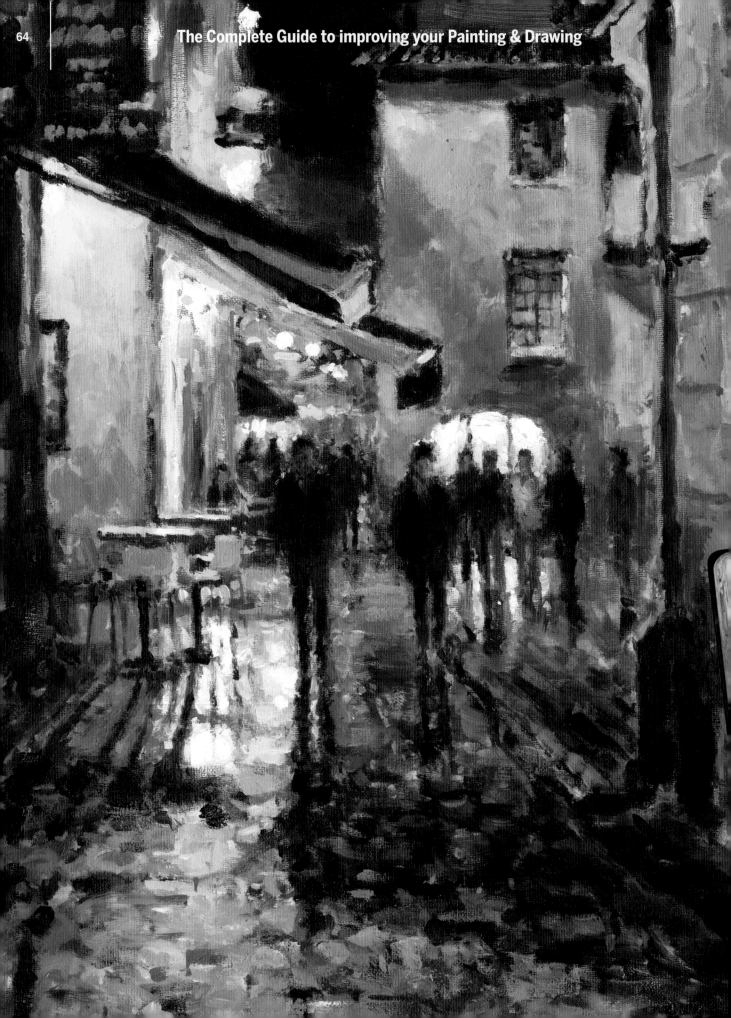

Capture a night atmosphere

David Farren creates an evocative after-dark scene using a limited palette of acrylic colours

Materials

- Winsor & Newton Artists primed canvas board, 60x60cm
- Artists quality acrylics: Titanium White, Alizarin Crimson, Cadmium Red Light, Raw Sienna, Cobalt Blue, Cadmium Yellow Medium, Ultramarine, Cerulean Blue, Burnt Umber
- Brushes: Flat – 1in and ¾in; Round – size 6; Rigger; 1½in decorator's brush

Painting busy streets can seem like a daunting challenge, but they are also an extremely rewarding subject matter. All the things that make up an urban scene – buildings, trees, cars, people and street furniture can combine to create an exciting painting. Here I'm doing a studio painting of a street in Périgueux, using an on-location sketch and photographs for reference.

I was drawn to the warm yellows of the artificial lights on the stone of the buildings, and the strong contrast between the reflections on the pavement and the silhouetted figures. The street already has a good composition with the buildings framing the bright cobbled road that leads the eye into the painting, while the people added life and movement. When painting a complex subject it's good to simplify what you see or you'll get bogged down in detail. It's also important to stay focused on what inspired you in the first place and make it the focal point of the painting.

I'm going to be painting with a limited palette of acrylics. One of the main features of this medium is the quick drying time, so if you want to blend or smudge you have to work quite quickly. I like the brushwork and texture that comes when making rapid marks with heavy-body paints.

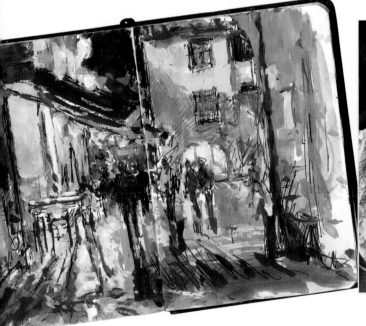

1 ◐ Sketching the scene

First I make a sketch of the street in the old town area of Périgueux using a 0.5mm fineliner pen. I then add colour over the top using gouache, trying to get down the main elements of the scene. I also take reference photos to help with details in the finished painting.

2 ◑ Preparing the palette

Back in the studio I start by laying out the acrylic paint on my palette. I use plenty of paint and lay the colours out in groups of yellows, reds and blues.

Reflect on your work

Use a small mirror to view the painting as this helps you to see it with 'fresh eyes' and spot any errors, such as leaning people or wonky buildings.

3 ❶ Prepare the board

I apply a thin wash of Raw Sienna and Alizarin Crimson to a sqaure canvas board, using a 1½in decorators brush, and let it dry. This provides a warm base colour for the painting and will take away the whiteness of the board. Areas of this wash will still be visible in the finished work.

4 ❷ Identify the major elements

I load a ¾in flat brush with some Raw Sienna and Burnt Umber, then outline all the major elements, paying attention to the scale of the buildings and figures. I try to be reasonably accurate, but also try to keep it loose. I add more figures and change their positions.

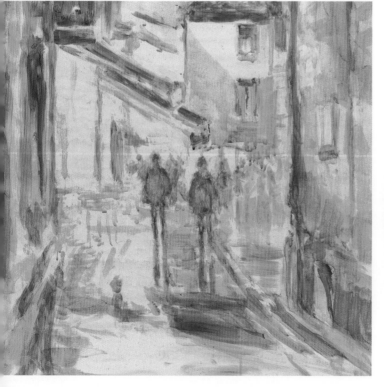

5 ❸ Block in the shapes

I am now thinking about tone, i.e how light or dark an area is. I quickly lay in some bigger shapes of the shadowed buildings using variations of a mid-tone mix of Raw Sienna, Crimson and Ultramarine using the ¾in flat brush.

6 ❹ Add the shadows

Using thicker paint, I brush in the darker areas of the awnings and the buildings in shadow. Keeping the strokes loose and painting quickly, I work on all parts of the painting in the same way to give the painting a consistent feel.

7 ○ Add some light

Now that the mid to dark tones are painted, I add some of the warm yellow colour where the walls are lit by artificial lights. Using a mix of Raw Sienna, Cadmium Yellow and Titanium White, I use the ¾in flat brush to bring in the colour, gradually increasing the Titanium White nearer to the light source.

"I work on all parts of the painting the same way to give it a consistent feel"

8 ○ Paint the foreground

I've come to the lit area of cobbles in the foreground. I want to keep it simple and suggest it with just a few strokes of the flat brush. I vary the colour as I paint from a creamy green on the right to a lighter pink colour on the left.

Wanderlust inspiration

My first trip to New York in 2001 was a breakthrough moment for me. I felt really inspired by this amazing city and spent my time walking the streets and sketching. I exhibited a series of paintings from the trip at a UK art fair, where it received a fantastic response and all my paintings sold. This gave me the boost I needed to become a full-time artist.

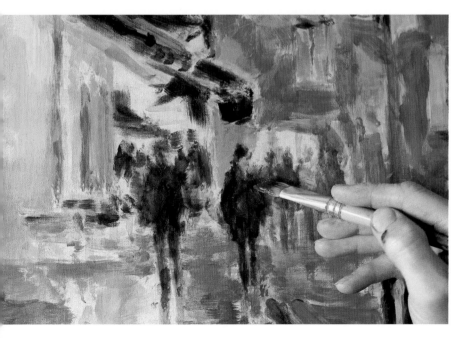

9 ○ Work on the figures

At this point I need to do some more work on the figures. I paint them quickly using a dark mix of Ultramarine, Crimson and Burnt Umber and let the edges blur and merge to suggest movement. I also darken the reflections and define some of the lines of cobbles, which helps lead the eye into the painting.

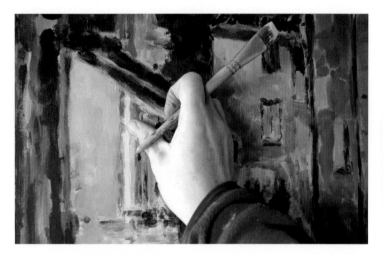

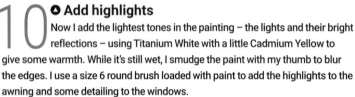

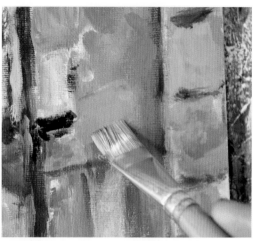

10 ⊙ Add highlights

Now I add the lightest tones in the painting – the lights and their bright reflections – using Titanium White with a little Cadmium Yellow to give some warmth. While it's still wet, I smudge the paint with my thumb to blur the edges. I use a size 6 round brush loaded with paint to add the highlights to the awning and some detailing to the windows.

11 ⊙ Use the shape of the brush

Here I'm painting the building on the right using the square shape of the flat brush to indicate the blocks of stone. This wall is lit by white light so I use a pinkish mauve mix of Titanium White and Cobalt Blue with a touch of Raw Sienna and Crimson.

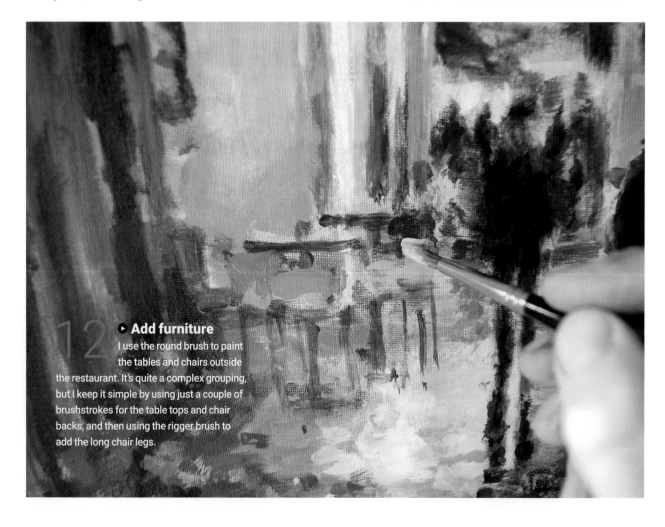

12 ▶ Add furniture

I use the round brush to paint the tables and chairs outside the restaurant. It's quite a complex grouping, but I keep it simple by using just a couple of brushstrokes for the table tops and chair backs, and then using the rigger brush to add the long chair legs.

13 ⊙ Paint the blue reflections

Now is the time to add the blue reflections from the distant lights. Loading a brush with Titanium White and Cerulean Blue, then adding some Cobalt Blue for the darker areas, I roughly brush in the paint in varying strokes trying to create some interest and suggest the uneven nature of the cobbles.

14 ⊙ Add texture

The area of bright white reflection is strengthened using a 1in flat brush, which I also use to add more pink to the reflections on the cobbles, dragging the brush down over the surface of the board to create texture. I also add more texture to the yellow walls with further brushstrokes of thick paint.

"I drag the brush down over the surface of the board to create texture"

15 ⊙ Make final adjustments

At this stage I make final adjustments to various elements of the painting. I decide to darken up and add more texture to the foreground cobbles. I also make the lights in the far window brighter with some Titanium White applied with my thumb. Finally, I add the writing on the sign in the top left, which is kept very loose and just hinted at. A few minor changes to the figures and that's it!

Create a modern Impressionist scene in four stages

Tony Belobrajdic shows how he uses a loose and spontaneous method to paint a lively indoor scene

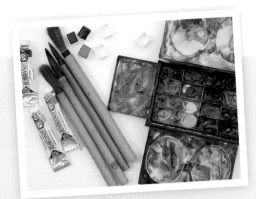

Materials

- Royal Talens Rembrandt watercolours (tubes)
- Arches rough watercolour paper, 300g
- Japanese/Oriental style soft goat-hair brushes, medium to large (8, 10, 12)

Over the years I've developed my style of painting by looking closely at the work of the Impressionists. Their art was fresh and spontaneous, and was executed with bold brush strokes, which didn't reveal too much detail. For this workshop, I'll paint a contemporary café scene in watercolour using their methods (and a photograph) for reference.

Impressionistic techniques also match the essence of painting with watercolour. Washes are applied with one decisive brush stroke, and are never corrected or smoothed out. This gives the painting an almost unfinished look, enabling the viewer to finish the picture.

I usually try to create a painting in four stages. First, I visualise how I want the final painting to look. You can produce a small pencil sketch or tonal study, if it helps. This stage will help cement the composition, the focal points and sources of light.

I then start to paint very basic shapes with a large brush. This sets the tones and overall mood of the work. At this stage you should avoid adding any details and leave large areas of paper untouched. Next, once everything's dry, I turn the basic shapes into more 3D objects by painting shades and shadows, reflections. I also start adding in people (though I did this early in this painting), while still avoiding any details.

Finally, it's the fun part: adding in details and accent colours. Painting with either the tip of the brush or a smaller brush, I use thicker pigments and explore dry brush effects. At this point, it's best to hold back in case you overwork the composition. Slow down and paint decisively and then leave it alone. Remember, it's for the viewer to 'finish the picture'.

In front of you

Inspiration can come at any time. More often than not it's always there, just waiting to be triggered by visiting an art gallery, opening Turner's book or even having a good cup of coffee.

1 ◗ Start with light colours

Find the focus of your painting. For my picture, this will be the window and the waiter. I mix a light wash for the walls and paint in that area. Making sure I follow the correct perspective, I have the left and right window visible in the picture. I then start to paint in the background around the waiter.

2 ◗ Add the figures

Using a thicker mix of black, Ultramarine Blue and a bit of red, I paint the person on the left, as well as the waiter's trousers and head. I leave an unpainted area for the two chairs in front of these figures. I will use this negative-space painting method throughout the scene.

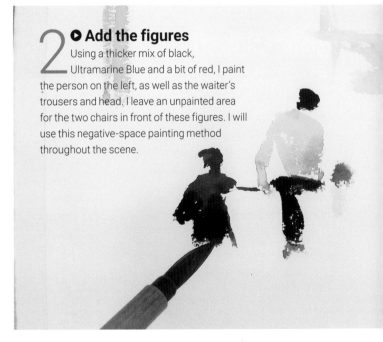

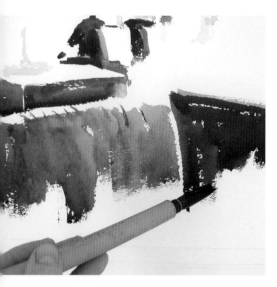

3 ◐ Paint the foreground
Moving to the bottom of the paper, I paint the foreground. Using lots of water and pigment, I create swift, spontaneous brush strokes with my largest brush. I leave the top of the chairs unpainted.

4 ▶ Add the tables
Continuing with a dark colour, I make the paint a bit thicker and hold the brush at a steeper angle to the paper, to paint the round tables. I leave the tops white and paint in the reflections with vertical strokes, using more water. Every brush stroke is done once, then left alone.

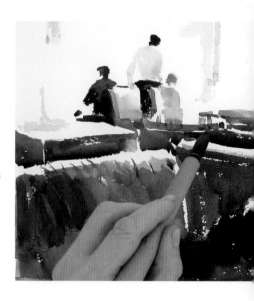

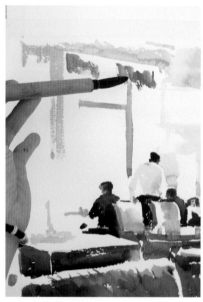

5 ◐ Paint the curtains and reflections
I paint reflections on what looks like two mirrors in the centre. For the red curtains I apply a dark tone on the top of them, using wet-in-wet. The colour will run a bit with this technique, but don't try to correct anything. It's tempting to add details, but leave them for last.

6 ▼ Paint quickly
Now I go to the top left-hand side to add in a grey/blue colour. I try not to be precise, because this isn't an important part of the painting. It's even better if it's painted quickly in an almost abstract manner. I now step back, take a break, and assess what I've done so far.

Brushstrokes
The soft goat-hair brushes that I use hold plenty of water and make broad strokes. They also add looseness and spontaneity to the painting because they can produce some unusual marks. I hold them halfway up the handle to free the stroke even further. For the initial brushwork, I lay them flat, and for adding detail I hold them perpendicular to the paper, using only the tip of the brush.

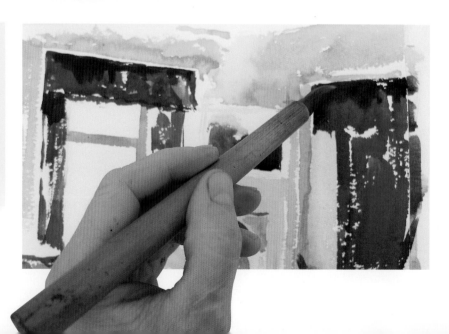

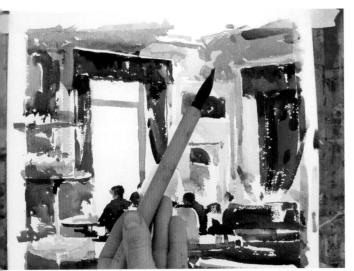

7 ◐ Paint the ceiling

I mix dark greys and use more water and a larger brush to paint the ceiling. This is the last area to be finished before I start on the shadows. With the tip of the brush, I roughly paint in some details, such as the cornice details where the walls meet the ceiling.

8 ◐ Fill in the shadows

In the reference photo the light is coming through the windows, so I paint the shadow line at approximately 45 degrees on the wall. For shadows, I use a grey-blue mix. It should be watery and transparent, but with enough pigment so that I only have to paint it once.

9 ◐ Add details

I take a thick dark pigment and practice on a piece of paper to check the brushstrokes. They should look like they were painted with a dry brush. I work with short, thick strokes, only adding in a few details from the photo. I have also added some light ochre to the bottom of the pane.

Late starter

I came to watercolours quite late in life. The simplicity of the setup and preparation was an attraction. I soon discovered the other side of watercolours: no over-painting, correcting or changing anything in the process. After several years of learning, I'm painting more freely now, and not using a pencil sketch as a base.

10 ◐ Observe the final picture

If you stand back, you'll see many areas that could be improved or areas where more details could be added. Don't do it! The only things I add are a few broad strokes indicating creases in the fabric at the bottom of the picture. I also make the very bottom of the picture darker, so as not to draw attention to that area.

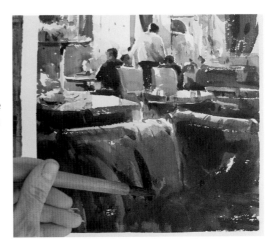

Draw a figure in under five minutes

Get the most out of your life-drawing sessions with
Chris Legaspi's quick tips for quick figures

Sketching a five-minute pose is a lot of fun because it offers just enough time to capture a strong sense of the pose, but not enough time to overwork (or overthink) the drawing. Keeping things simple and being economical is a recurring theme throughout the five-minute process.

The main thing to remember for a successful quick pose is to keep the gist of the subject, so I'll show how to first create three defined sections of rib cage, abdomen and hips. Then, I'll add in the natural tilt and rotation of the head to instantly make the subject more believable, while filling in the

key features and details to help bring the whole figure to life. Next, adding limbs as flowing tapering rectangles adds movement and energy to the pose, with added cross sections defining their position and direction. I start the hands and feet with simple ovals, squares or triangles to capture their shape.

Finally, if the lighting is flat, I'll add details with line and construction. If the lighting is good and the shadows are clear, I'll use tone to define the anatomy. Let's get started!

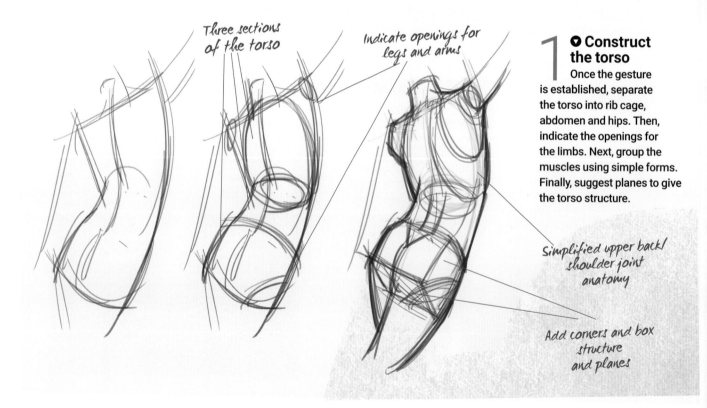

Three sections of the torso

Indicate openings for legs and arms

1 ◐ Construct the torso

Once the gesture is established, separate the torso into rib cage, abdomen and hips. Then, indicate the openings for the limbs. Next, group the muscles using simple forms. Finally, suggest planes to give the torso structure.

Simplified upper back/ shoulder joint anatomy

Add corners and box structure and planes

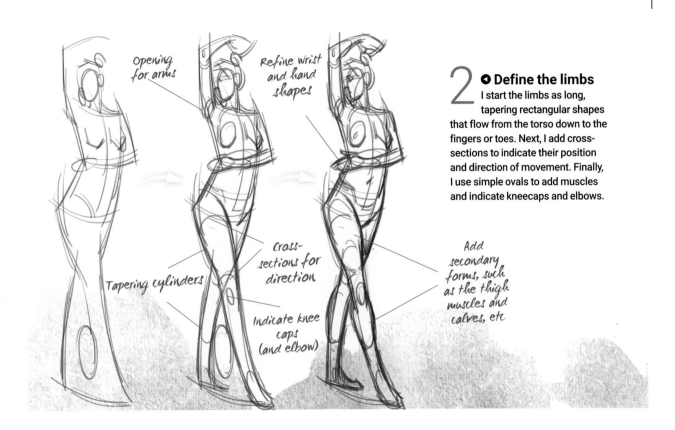

opening
for arms

Refine wrist
and hand
shapes

Tapering cylinders

Cross-
sections for
direction

Indicate knee
caps
(and elbow)

Add
secondary
forms, such
as the thigh
muscles and
calves, etc

2 ○ Define the limbs

I start the limbs as long, tapering rectangular shapes that flow from the torso down to the fingers or toes. Next, I add cross-sections to indicate their position and direction of movement. Finally, I use simple ovals to add muscles and indicate kneecaps and elbows.

3 ○ Simplify the anatomy

Starting with the torso, I group the upper-back muscles (which surround the shoulder) into simple forms. Where visible, I emphasise hip bones, knees and elbows. Finally, I emphasise the parts where muscles overlap, which creates the illusion of more detail and brings the drawing to life.

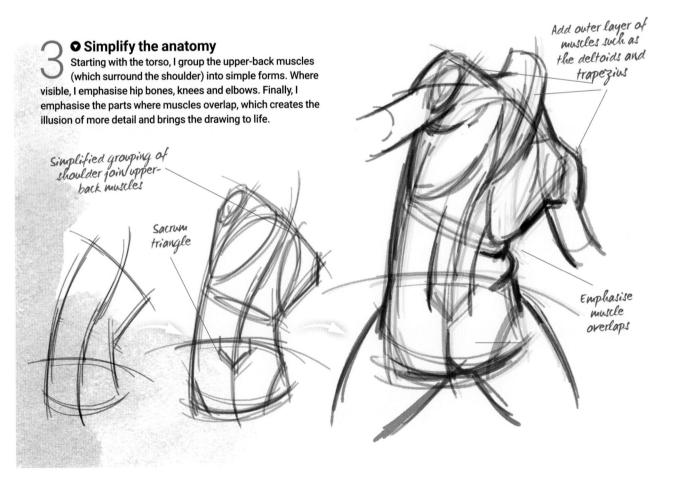

Simplified grouping of
shoulder join upper-
back muscles

Sacrum
triangle

Add outer layer of
muscles such as
the deltoids and
trapezius

Emphasise
muscle
overlaps

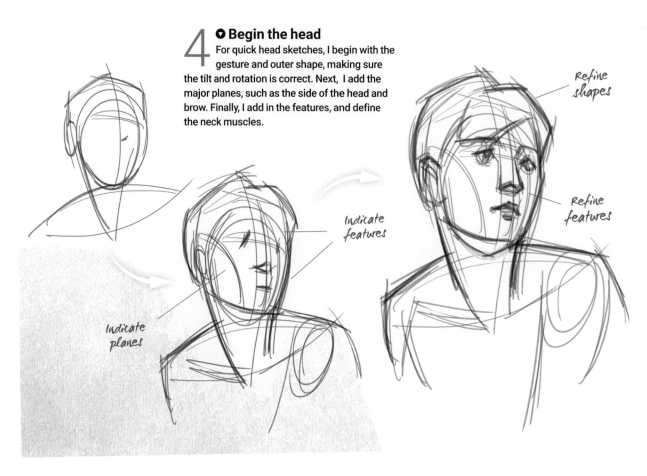

4 ○ Begin the head

For quick head sketches, I begin with the gesture and outer shape, making sure the tilt and rotation is correct. Next, I add the major planes, such as the side of the head and brow. Finally, I add in the features, and define the neck muscles.

Refine shapes

Refine features

Indicate features

Indicate planes

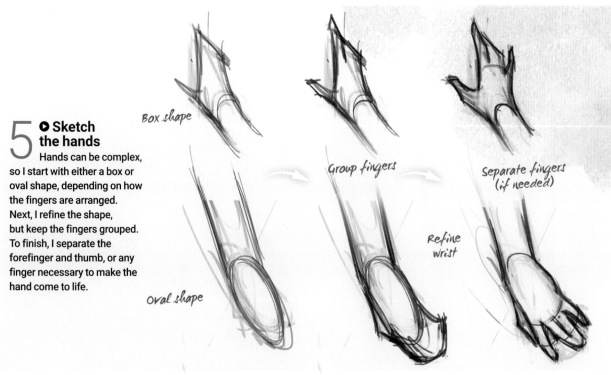

5 ○ Sketch the hands

Hands can be complex, so I start with either a box or oval shape, depending on how the fingers are arranged. Next, I refine the shape, but keep the fingers grouped. To finish, I separate the forefinger and thumb, or any finger necessary to make the hand come to life.

Box shape

Group fingers

Separate fingers (if needed)

Refine wrist

Oval shape

6 ◐ Sketch the feet

The feet are fairly easy to simplify since the toes are short and clustered together. Start with a triangle shape to capture the gesture, making sure to emphasise the contact point. Next, refine ankle and shape of the grouped toes. Finally, separate the big toe, or any other toes as needed.

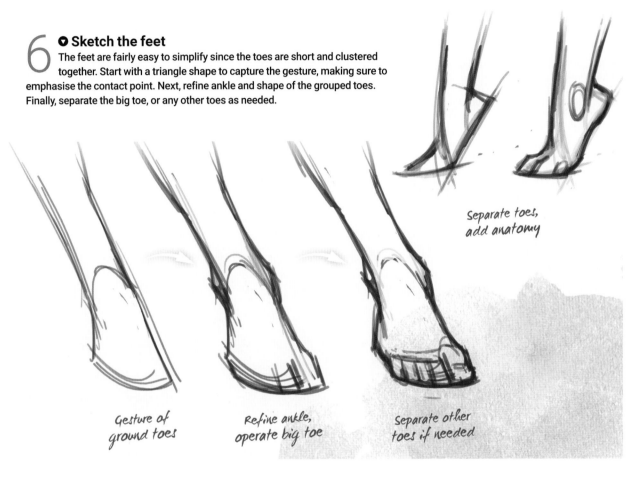

Separate toes, add anatomy

Gesture of ground toes

Refine ankle, operate big toe

Separate other toes if needed

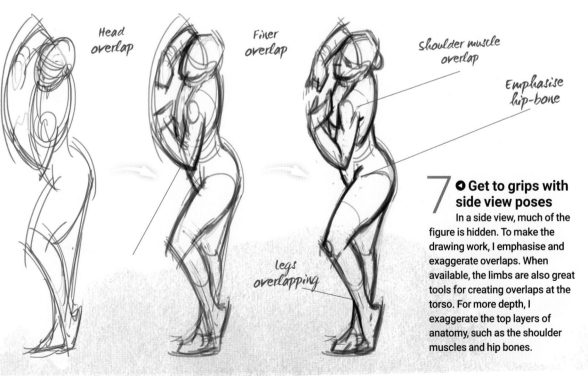

Head overlap

Finer overlap

Shoulder muscle overlap

Emphasise hip-bone

Legs overlapping

7 ◐ Get to grips with side view poses

In a side view, much of the figure is hidden. To make the drawing work, I emphasise and exaggerate overlaps. When available, the limbs are also great tools for creating overlaps at the torso. For more depth, I exaggerate the top layers of anatomy, such as the shoulder muscles and hip bones.

8 ⚙ Work with foreshortened poses

Similar to a side view, I emphasise overlaps. If the torso is moving away, I emphasise the overlap of the hips and abdomen. If the torso is coming toward me, I use the rib cage and anatomy to create overlaps. If visible, the limbs drawn with good cross-sections can also create depth.

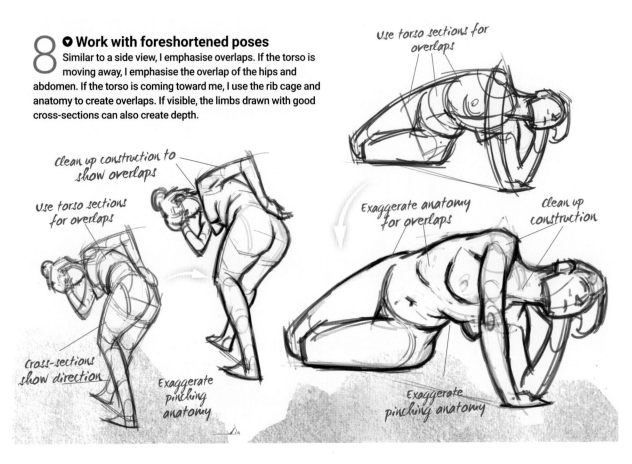

use torso sections for overlaps

clean up construction to show overlaps

Use torso sections for overlaps

cross-sections show direction

Exaggerate pinching anatomy

Exaggerate anatomy for overlaps

Clean up construction

Exaggerate pinching anatomy

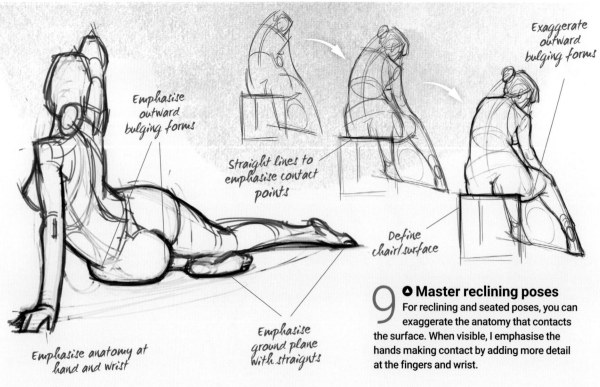

Emphasise outward bulging forms

Straight lines to emphasise contact points

Define chair surface

Exaggerate outward bulging forms

Emphasise anatomy at hand and wrist

Emphasise ground plane with straights

9 ⚙ Master reclining poses

For reclining and seated poses, you can exaggerate the anatomy that contacts the surface. When visible, I emphasise the hands making contact by adding more detail at the fingers and wrist.

10 ● Add tone

If the lighting is good, I will often finish the sketch with tone. One way I do this is by blocking in the shadow and filling in the shape with a suitable tone.

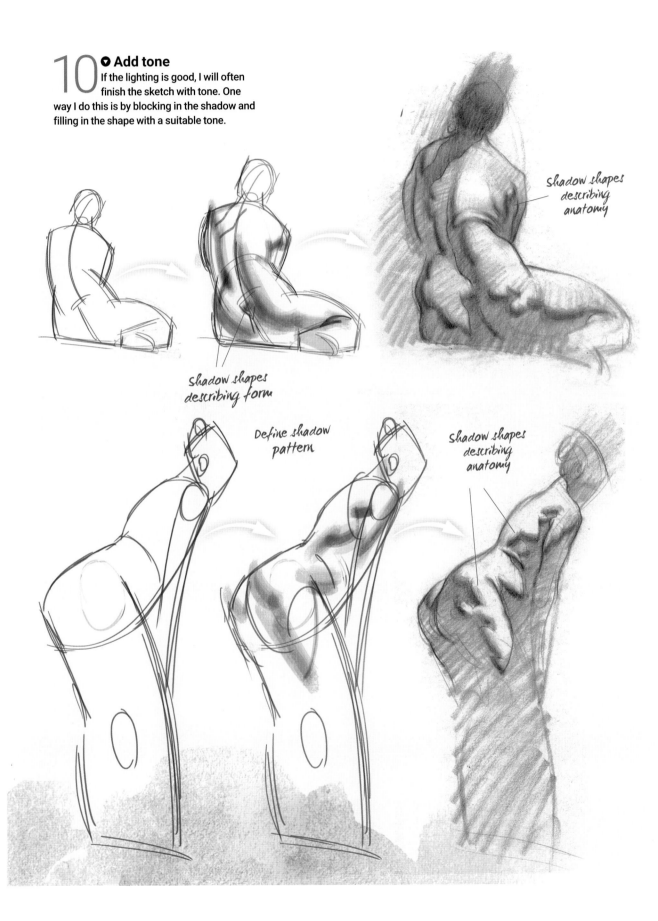

shadow shapes describing anatomy

shadow shapes describing form

Define shadow pattern

Shadow shapes describing anatomy

Add dramatic light to your wildlife paintings

Wildlife artist **Tony Forrest** shows you how to paint warm sunlight to give your animal paintings depth and colour

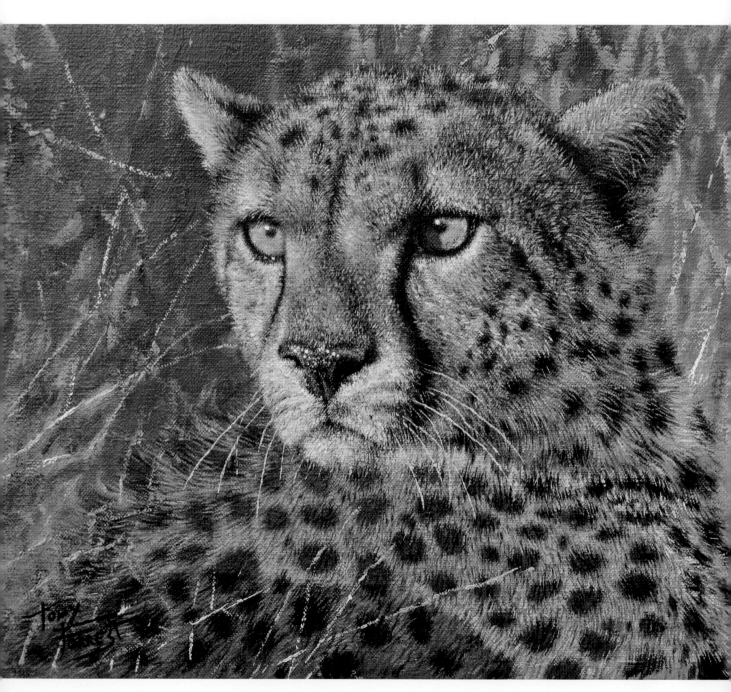

Materials

- Oil colours: Burnt Umber, French Ultramarine, Quinocridone Violet or Crimson, Cadmium Red, Cadmium Yellow, Cadmium Orange, Lemon Yellow, Winsor Blue or Cerulean Blue, Winsor Green, Titanium White
- Brushes: Hog (No.7 Long Flat, No.1 Long Filbert), Sable (No.0 Round), Sable/Synthetic mix (No.0 Rigger)
- Stretched linen canvas 10x12in
- Winsor & Newton Liquin

Even though I've been painting the wildlife of Africa for nearly three decades, it never fails to captivate me each time I visit. Africa has seemingly endless sunlight that flows across the landscape like a golden river. The animals themselves attracted me at first, but I soon began to realise the importance of portraying sunlight in my work.

This workshop explains how to convey warm sunlight in your paintings. Don't feel daunted by the subject and detail; with careful use of colour you will have great fun! Africa is a blaze of colour and light, and this is what you need to concentrate on from the start. The detail will be applied later on, refining as we progress. Even though this cheetah has a lot of detail, I focus more on the warm colour of the light, and cool colours in the shadows. Exciting warm sunlight will always make a simpler painting far more appealing than a detailed painting with dull flat light. At the beginning, you need to use quite strong colours.

Keep checking your painting against the photo, but try not to copy every detail. Be creative

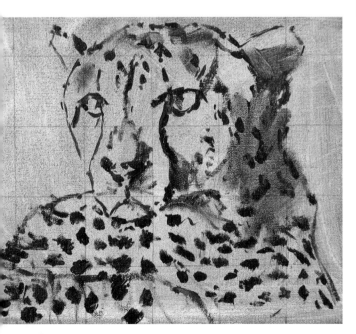

1 ◑ Draw a basic outline

Start by drawing the outline of your subject using any oil colour that has been thinned with Liquin or similar. Using a grid, to make the drawing as accurate as you can. Don't worry about details for now – you just need to make sure the main areas are in the right place. Make sure the eyes and mouth are the correct proportions. Check the drawing against your reference photo.

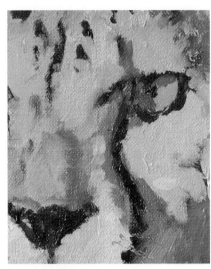

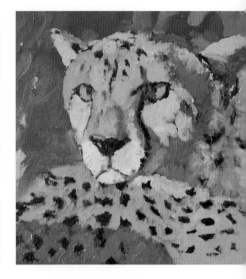

2 ⊙ Mix your colours

Using Cadmium Orange, Cadmium Yellow and Titanium White mix a warm mid-orange/yellow. Now add a little Ultramarine Blue, to calm down the brightness slightly. You will have to judge the strength of the colour as you paint, but it can be fairly bright at this early stage. Try to vary the colours to add interest.

3 ⊙ Block in colour

Noting the main areas of tone, start blocking in colour, applying the paint using Liquin – be careful not to lose your original drawing. Use subtle variations of colour and tone to retain life and interest. The shadows can be quite strong cool colours at this stage, contrasting with the warmer colours in sunlight.

4 ⊙ Check the light

Check the sunny effect is working – it should be unmistakable. At this stage, you can rub the paint off with a rag if you need to correct it. If you need to correct the colour, try not to apply more paint on top, as you will get into a mess! Add warm greens to the background.

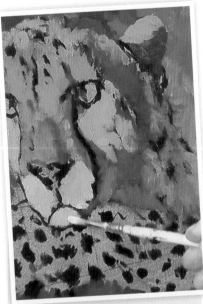

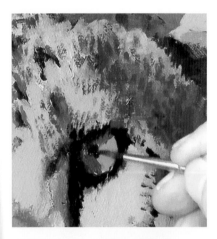

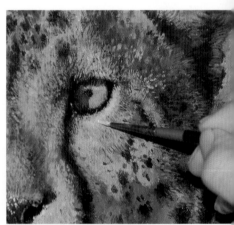

Time to shine!

To get a sunny effect from the start, mix warm colours with cool shadows. This is the most exciting part of the entire process!

5 ⊙ Start adding detail

Once the first layer is dry, add in detail. Don't use white, but add orange or yellow for the lightest areas. For the darker markings, mix any dark, warm tones using Burnt Umber, Cadmium Red or orange and yellow. Use Ultramarine Blue in the mix for the cooler tones in the shadows. Avoid black.

6 ⊙ Add the spots

Paint in more darks and lights with a fine round sable-type brush, creating the spots and other details. Look for subtleties in the fur. We'll be refining these details later, so there's no need to get too bogged down.

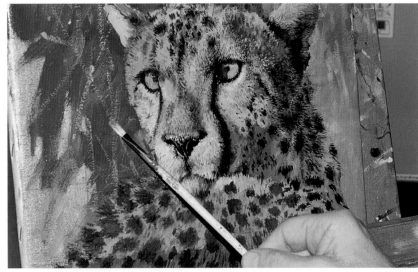

7 ○ Mix your greens

Mix some Winsor Green with Cadmium Yellow Light or Lemon and a bit of white. Add Cadmium Red if you need to reduce the intensity. Mix some light, bright greens and some darker tones to apply around the cheetah's head. There is no specific rule here, just do whatever looks right to you, retaining the sunlight effect.

8 ○ Paint the background

The background is deliberately left very loose. Here, I now pay attention to the contrasting colours on the left of the face and the bright warm greens just behind the neck on the right. With thick paint I hold the filbert brush very loose and let the paint drag across the canvas to suggest foliage and twigs.

Find your style!

I remember my first sold-out show when all ten of my paintings went in about four hours. I knew I was doing something right. It's important to have faith in your art – when you find your own technique, nurture it and it will become your best friend.

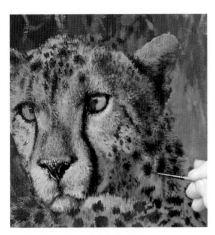

9 ○ Break the edges

Study your reference, and add detail to any areas that seem blotchy. Use a fine brush to add flecks of lighter thick paint to break up the edges of the darker spots. Make sure your shadows and sunny areas are still obvious. And make sure the 'white' parts of the fur are pale orange/yellow.

10 ○ Make finishing touches

At the end, study the painting to see if it needs anything you think might improve it. It might need a bit more contrast here and there, or maybe slightly brighter highlights on the face and so on. Spend a bit of time with your work and modify it until you are happy.

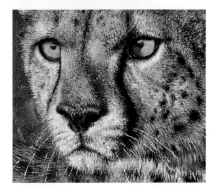

Make spontaneous bees and butterflies

Kate Osborne reveals the secret to creating unique art with wet-in-wet watercolour, gouache and unusual printing techniques

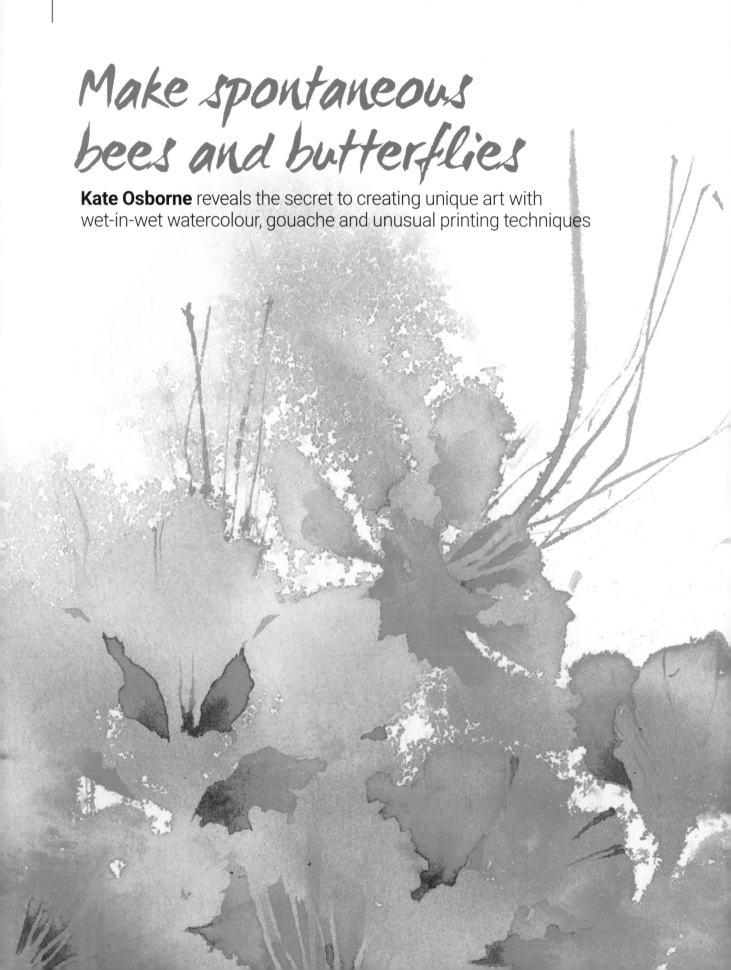

Nature offers so much inspiration for art. I began painting butterflies after a visit to my local natural history museum in Brighton, where I was able to access drawers and drawers of beautiful and fragile specimens.

I felt particularly inspired – after seeing the butterflies up close – to recreate some of the interesting textures. There are many ways to do this, and one way is to paint through tissue. This conveys some of that less-than-perfect, crumbling texture at the edges of the wings. It's also fun, and has results that are a little unpredictable and exciting.

Painting bees doesn't need the same treatment as butterflies, but you still need to keep looseness and wetness in your approach to painting them. This, of course, requires the right brushes and careful timing in order to keep the yellows separate from the blacks, and also to hang onto the delicate transparency of their wings.

Working small does not necessarily mean working dry, and remember that puddles of paint can dry in a very dynamic way. This workshop encourages you to keep it simple, taking a risk by allowing the paint to do its own thing, and find new ways to make marks and textures, and enjoy the dynamic results!

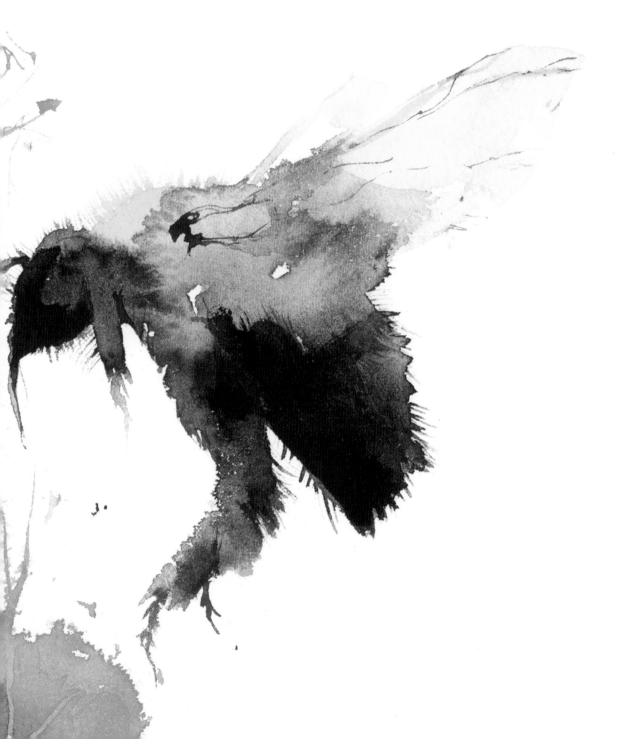

Bee inspired

1 Begin with yellow

Start by mixing good puddles of Cadmium or Hansa Yellow, Burnt Umber and/or Burnt Sienna, and Paynes Grey. Now take the palest colour (the yellow), and paint the whole body and head, keeping everything wet by dropping in more paint, or adding clean water. Add the wings in a pale mix of brown, and if the yellow bleeds into them, mop it up and drop a little clean water into the area – this will 'push' the yellow away.

Best brushes

It's best to use a round brush with a good point; sables are brilliant. Look for a brush that has enough body to hold a significant amount of paint, but can still keep its point. For very fine detail of the veins on the wings or the end of the legs, a sword brush is ideal. For the darker hair on the body, you can use a round Chinese brush with the tip flattened into a comb.

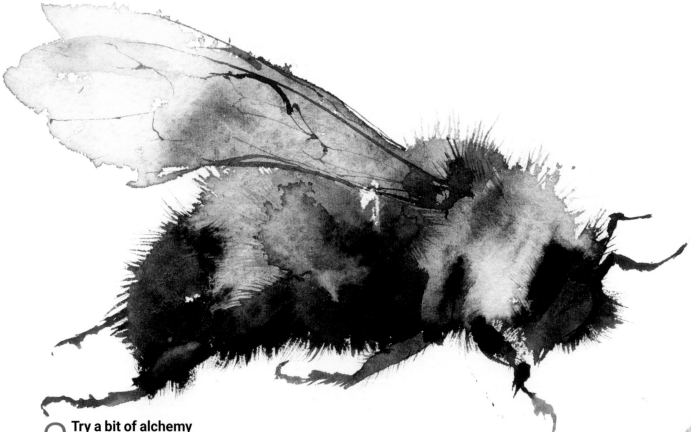

2 Try a bit of alchemy

Now drop in a rich shade of brown (or brown/grey mix) for the darker areas of the body furthest away from the yellow. Depending on how wet your paint is, how wet the area you are dropping it into, and how loaded your brush is, will dictate how much and how far this darker tone bleeds. Learning this bit of alchemy will take some practice and patience! Now let your painting dry completely.

3 Add the legs

With a darker mix of brown/black, find the negative shapes of the legs that are against the body, and paint the body around them. Try not to put in every detail – sometimes the smallest suggestion is enough and lets the viewer 'complete' the picture for themselves.

Water ways

The paint in your palette should, when you pull your brush through it, move like water. It should also have enough pigment in it so it doesn't merely look 'tinted' when it goes down on the paper.

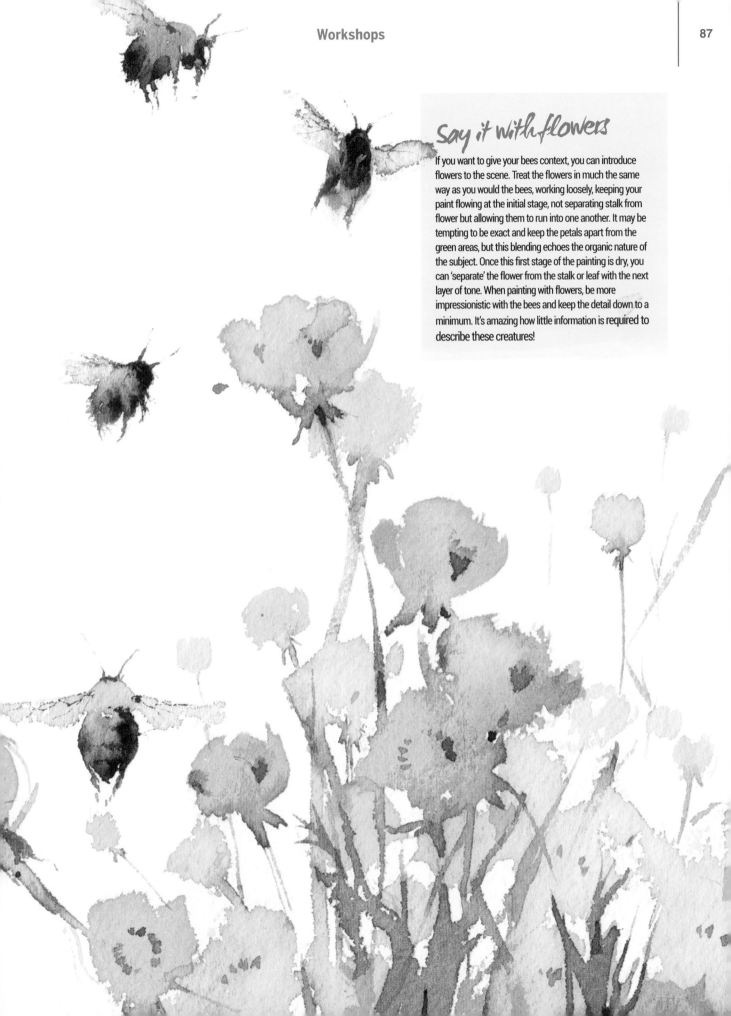

Say it with flowers

If you want to give your bees context, you can introduce flowers to the scene. Treat the flowers in much the same way as you would the bees, working loosely, keeping your paint flowing at the initial stage, not separating stalk from flower but allowing them to run into one another. It may be tempting to be exact and keep the petals apart from the green areas, but this blending echoes the organic nature of the subject. Once this first stage of the painting is dry, you can 'separate' the flower from the stalk or leaf with the next layer of tone. When painting with flowers, be more impressionistic with the bees and keep the detail down to a minimum. It's amazing how little information is required to describe these creatures!

Better butterflies

1 Shape, colour and texture

Because butterflies are symmetrical, you can draw one half onto a folded sheet of tracing paper, turn it over and trace onto the other half. Once you've transferred the outline onto watercolour paper, create the initial stage of your painting, using some nice puddles of paint – make sure the whole area is covered. Before it has a chance to dry, place a layer of kitchen roll over the image and let it absorb the paint. You can now add rich, vibrant (and very wet!) colour on top. I've used mixes of Cobalt Teal, Perylene Red, Viridian and Indigo. Leave the tissue on until it is a little short of dry, before peeling it off for some lovely textures.

2 Add in the detail

I take a strip of masking tape and tear it down the middle, before sticking it onto the image, leaving a small gap. I then paint over the gap with blue gouache. When the tape is removed, it will leave an irregular-edged blue stripe for detail on the wing. I then make another longer stripe, this time running the entire length of the wing. There are now two stripes on the top wing, and just one on the bottom wing. I repeat this on the other side.

3 Add more detail

The hairs of the butterfly's body can now be painted on with a round brush flattened into a 'comb'. The wing veins are painted with a sword brush. For the red part of the wings, I've taken some Chinese/tissue paper and painted it with a rich mix of red paint. Once dried, I tear it into two circles. Next, I paint some textured craft paper with bright red gouache, and use this to print onto the tissue. The circles are then stuck onto the wings with glue. Finally, I print on the yellow gouache dots using my finger.

With a trace

You are looking to get the pattern as near symmetrical as possible, so it may be worth using your tracing paper again to ensure this, if you're not confident doing it by eye.

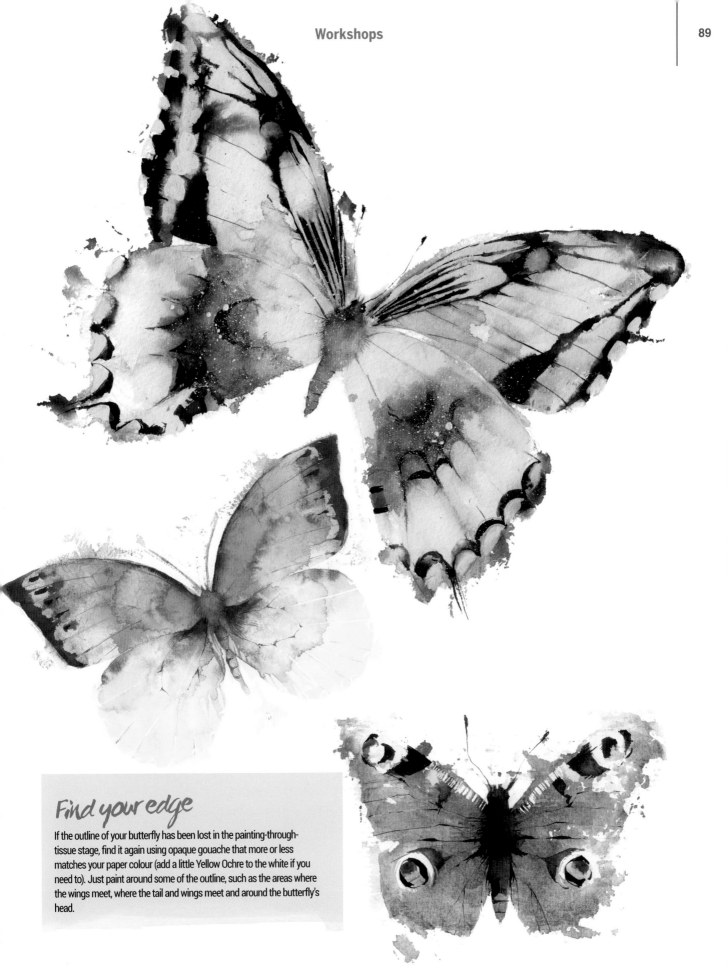

Find your edge

If the outline of your butterfly has been lost in the painting-through-tissue stage, find it again using opaque gouache that more or less matches your paper colour (add a little Yellow Ochre to the white if you need to). Just paint around some of the outline, such as the areas where the wings meet, where the tail and wings meet and around the butterfly's head.

Materials

- Daler-Rowney Georgian oil paints (Titanium White, Ivory Black, Ultramarine Blue, Burnt Umber, Yellow Ochre, Cadmium Red)
- Brushes: ¾" flat wash synthetic sable, ⅕" flat, 00 synthetic sable, 1½" flat (for gessoing), palette knife
- 40x60cm 6mm MDF board
- Acrylic gesso
- Sandpaper
- Low-odour thinner
- Paper towels
- Mahlstick

Paint your pet from a photo

Kate Oleska reveals her approach to re-creating the fluffy fur of your pets in this fun workshop

P ainting pets can be a lot of fun. While it's great to see the artwork finished and ready to hang on a wall, the process itself brings a lot of satisfaction. And, it's not just about copying a photo. An important part is also expressing yourself through your brushstrokes and artistic decisions. In other words, take the reference and make it your own, because that's what really makes a painting stand out!

I admire the grace and beauty of animals, and I love painting fur and seeing brushstrokes come to life and become something you could almost touch. And, although you can use different mediums to achieve that effect, I use oils because it's my favourite medium. In this workshop, I will show you my technique and offer tips on how to improve your painting. Some of the tips also work if you're painting a portrait of a person or even a landscape.

I will also tell you how to prepare your painting surface. Painting on board will allow you to convey the texture of your subject more effectively. However, painting on canvas works just as well.

Picture purr-fect

To paint a good pet portrait you'll need a good photo. That means the pet should be well lit and lying, sitting or standing in a comfortable position. The photo needs to clearly show the pattern of fur – use the image to establish anatomy and likeness but don't obsess about each strand of fur.

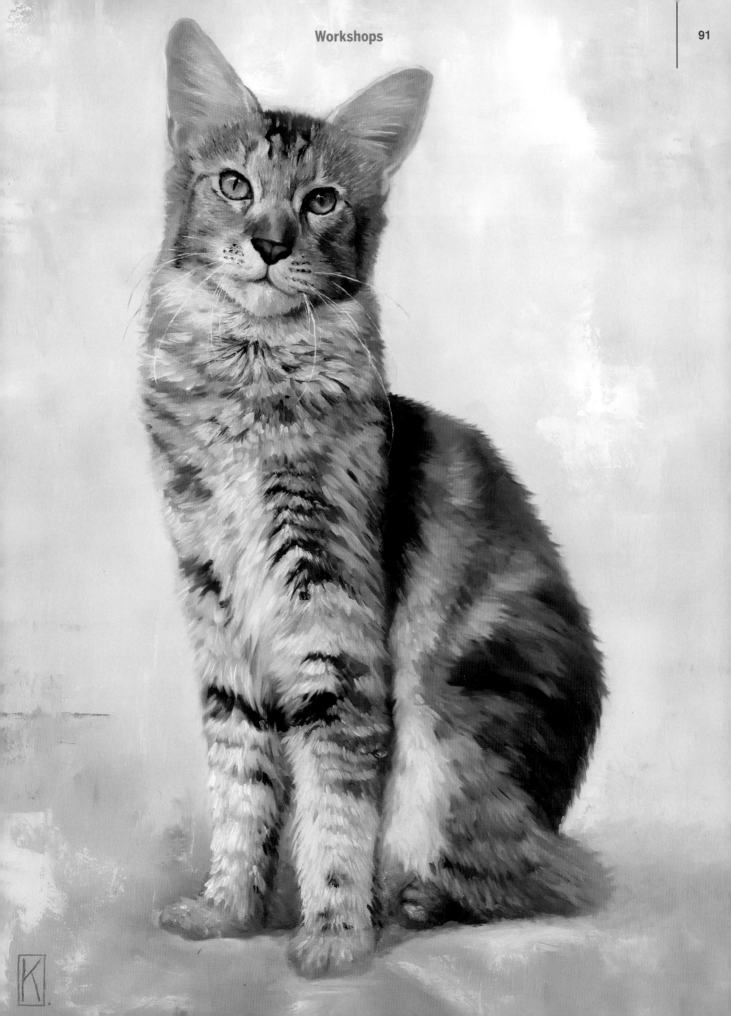

1 ◐ Prepare the board

If you are using MDF, you will need to sand the board first. You can then apply three to four thin layers of acrylic gesso to the surface. Let each layer dry and sand it, before applying the next layer. Try and keep the layers thin, as thick layers are harder to smooth out.

3 ◐ Do an initial sketch

The more time you spend getting the anatomy and proportions correct at this early stage, the less correcting you will need to make later. Keep your reference photo to hand – or print it big – so you can compare it with the painting at all times.

2 ◐ Apply a wash

I create a wash using a mixture of burnt umber paint and thinner and apply it onto the board. White board can be very overpowering, so toning it with a wash will help you see the values better once you start to paint. I use burnt umber because it dries quickly.

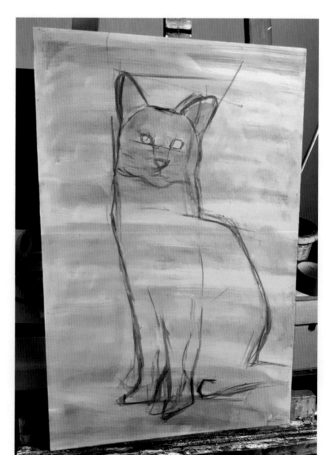

Be upstanding!

I always stand my brushes upright when they're not in use – this way they will last longer.

4 ◐ Paint the background

The background of a painting can strongly affect how colours work together, that's why it's the first thing I paint. It's also easier to focus on the subject when a large part of the painting is already established. I use a flat brush and palette knife to create the background.

5 ◐ Work on the eyes

Eyes are very important when establishing likeness in a portrait. It's important to remember that highlights appear on the surface of the translucent cornea, while shadows are created underneath, on top of the iris. This is especially visible in cats' eyes as their pupils are very narrow.

See the light

Make sure you have a steady and strong light source that falls onto your board evenly. It's also good to have your palette in an upright position (for example on a separate easel) next to your painting. Having the palette in the same light source helps when comparing colours.

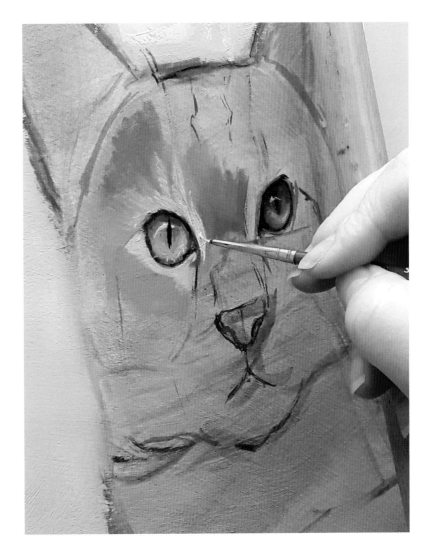

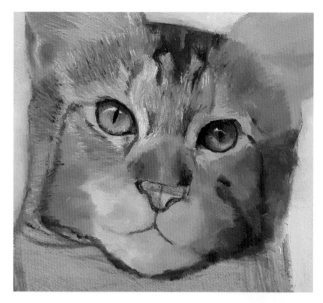

6 ◗ Paint the face

For the face, I first add a base colour to establish shapes and likeness. Once I have this, I start working on details (fur, ears, nose) using a fine 00 brush. I then gradually apply thicker layers of paint on top, working with two or more shades and trying not to mix them.

Time trial

It's worth knowing that different oil colours can dry at different speeds. Burnt Umber and Ivory Black dry very fast, while Titanium White can take days, even weeks to dry.

7 ◗ Add the fur texture

This cat is very fluffy and long and therefore fun to paint! Fur consists of different types of colours layered on top of each other. Each strand has a shadow and highlight defining its shape. I paint fur in sections applying darker colour (shade) first, then lighter colour (highlight) on top.

8 ◎ Create soft edges

In most paintings, you will have sharp edges while others are left soft. The transition between the fur and background should be fairly soft, but not blurred. Make sure soft strands of hair are still visible. Oils are very good for creating soft and hard transitions, so experiment a little.

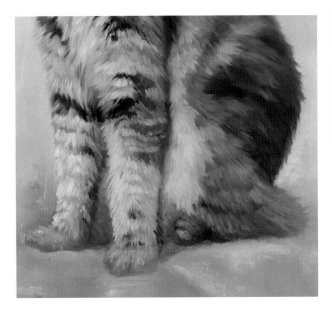

9 ◎ Make hard decisions

Sometimes I have to make last-minute decisions even when the painting is almost finished. At first I liked the composition, but when I finished the portrait the tail going out of the shot started to bother me. I decided to paint over it, therefore hiding it behind the cat. In the end, I feel it really helped the final composition.

10 ◎ Add whiskers

Whiskers should be painted after all the other layers have been rendered. You can wait until the painting dries before you apply them, but it's not absolutely necessary. I use the smallest 00 brush, applying paint slowly, but with a degree of confidence. As with the rest of the details steadying my hand with a mahlstick is essential.

Sign off!

Signing your painting might not seem important, but it is - this is your art! Make your signature visible but don't let it overshadow your painting.

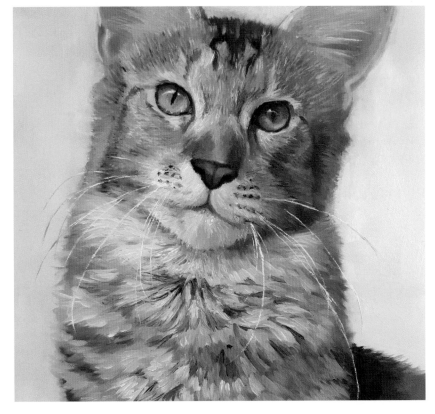

Find joy in painting outdoors

Concept artist **Bill Robinson** shows you how to get the most out of plein air painting

P lein air painting has been used by the masters for centuries. That alone can make it seem intimidating! I'm here to help you demystify the painting process, the gear, and show you how it's going to help you improve all aspects of your artistic work. I spent years thinking plein air painting was for serious artists, when the truth is that it's for anyone who wants to get out in nature and have some fun.

I first started painting outdoors because of peer pressure – a group of artists at the film studio I was working at had an established practice. I asked them how they had become so accomplished at painting colour and light and the answer was always the same: plein air. I got up the courage to join them and immediately understood what they were talking about. With daily practise, my paintings improved rapidly – and yours will too.

In this workshop I'm going to cover the gear that will make plein air painting comfortable and portable. We'll take a look at the keys to composition and how to hone your observational skills, then we will walk through a step-by-step painting out in the real world. Let's get started!

1 ○ Get the right gear

The equipment you use can determine whether or not you enjoy your plein air experience. You want everything to be as portable as possible. I use a Kelty Redwing backpack designed for trail hiking because it has room for everything and is comfortable. You will need a lightweight tripod as well as a pochade box to mount to it. The pochade box is a small box that unfolds and holds paintings and supplies. You may also want an umbrella to block out direct sunlight.

2 ○ Choose your tools

Plein air painting is suitable for any medium. My personal favourite is gouache paint, which is water soluble, dries quickly, and is very easy to transport. I use Holbein or Winsor & Newton gouache, and generally only use two or three brushes in the field. I work small, usually around 5x7in, and always start with my biggest brush, a 1-inch flat. I work down to small brushes as I get into details. I prefer hot press illustration board for gouache.

3 ○ Pick a location

Do you like privacy when you're out creating your art? If you aren't comfortable with strangers commenting on your work you probably want to head deep into nature and avoid busy streets. Both urban and natural settings offer a wealth of great subjects to paint, and you will be able to practise and learn the same amount from either. A good tip is to wear headphones if you want to avoid chatting with passersbys – or carry business cards in case people are interested in purchasing your paintings!

4 ○ What should I paint?

Once you've picked a location, scout the area for a subject. I tend to look for great lighting but keep in mind that it may change quickly. Also consider how much time you have – don't pick something complicated if you only have 30 minutes to paint. Don't be afraid to focus on small subjects like a flower. It's an idea to snap a photo of your subject when you first start to paint, in case you want to finish at home.

5 ○ Set up for success

A great plein air set-up will put all of your supplies at your fingertips. Your pochade box should be able to hold your paper or canvas, as well as a palette, towel, water, brushes, and at least a few tubes of paint. You don't want to interrupt your flow every few minutes to dig up a brush or colour. Pour out plenty of paint and mix any major colours you need before you get started.

6 ◐ Find an interesting composition

Your composition is perhaps the biggest factor in whether or not you create a successful painting. I like to use my fingers to form a viewfinder that will frame my subject. I then transfer the framing to my canvas as quickly as possible in a simple pencil sketch. Utilising the rule of thirds and avoiding tangents will go a long way to getting something decent.

Great idea!

Even a relatively simple scene will contain lots of detail that can overly-complicate your painting. To avoid getting overwhelmed, squint as you observe what to paint. Not only will this simplify what you see, and thereby help you decide what information to leave out, but it makes colours and tones easier to identify.

7 ◐ Work big to small

Try painting with the largest brush possible, for as long as you can. This will help you to see shapes instead of details, and will make you focus on the overall colour and value relationships of the image. When you feel like you simply can't get the detail you need with the large brush, jump down to a slightly smaller one, but avoid hairline brushes for as long as you can.

8 ◐ Observe colour

One of the most common problems for beginners is properly identifying colours. It's a lot harder than it sounds! We all know red from blue, but when you begin to get into the muddy world of browns, greys, and purples, things get a lot more complicated. Shadows can be warm, light can be cool... there are no hard and fast rules, just try to observe and exaggerate colour when necessary.

9 ◐ Don't be afraid to just try something out

Believe me, not every painting you do will be a masterpiece but that's how you know you are pushing yourself. It's important to leave your ego at home and take some days to mess around – try a new brush or a different type of paint. Set up a page of tiny thumbnails to study colour relationships. Try working big, try mixing media. Find out what works best for you.

Walkthrough
Put it all together

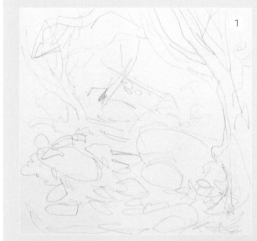

1 ◐ Before you worry about colour or value, take a few minutes to sketch in your composition. This can be a 30-second scribble, as long as it contains all the major elements of your subject. Don't worry about making it pretty, as it will be covered in paint shortly.

2 ▶ Lay in basic shapes with your largest brush. The goal here is to get rid of the white canvas and lay in simple colour and value relationships. Try to stay loose and really observe the light and shadow that describes the forms.

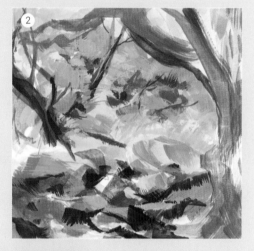

10 ◐ Pace yourself

It would be wonderful if we could spend all day painting outdoors, but chances are you will have a limited window of time. I like to have a couple of hours to create a painting that captures all the major elements of my scene. If I know I only have 30 minutes, I will approach things differently and am sometimes pleasantly surprised at how much looser and more alive my work feels with limited time.

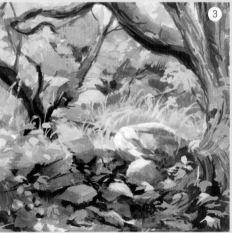

3 ◐ When you can no longer use that large brush, it's time to get into the fun part: details! This may be only the last few minutes you spend on a painting. This is your chance to make objects specific: the shape of leaves and grass, the texture of the tree bark and rocks, etc.

Express your abstract scenes with texture

David Body describes how he paints colourful, expressive landscapes with layered acrylics and emulsion on canvas

Materials

David used **Daler-Rowney Cryla Artists' Acrylic paints, Homebase tester paint pots** and **Berger satin emulsion paints**. He paints with **hog brushes** for drawing and underpainting, and uses **fine liners** for the detail. The canvas was a 76x51cm **Winsor & Newton primed canvas**. The paintings are finished with **Golden – MSA Varnish (Satin)**.

When I create my paintings, they're all about colour, composition and memory of a place, rather than a faithful representation of somewhere. I like to have fun and use paint in a decorative way. When painting scenes like the one in this workshop, I tend to use houses for a compositional affect rather than reality, and I always paint places I know well – working this way gives me the freedom to be flexible. I find if I work from drawings or photos of places I get bogged down with the detail and realism.

I tend to reduce the landscape to a pattern of flat coloured blocks, so I can then play around with the composition, size and tone in an almost abstract way. Tone is also used to flatten out the painting by putting the darkest colours furthest away, and placing the lighter ones in the foreground. This flattens out the houses, removing

perspective and making them all the same size. The opposite to what would be seen in real life!

I paint with heavy body acrylics and emulsion paints, which I get mixed for me as the colours are not readily available in the standard range. I start by laying out a basic colour palette of white, Yellow Ochre, Phthalo Blue (red hue), Cadmium Red, Alizarin Crimson, a mixed cyan, a mixed mauve emulsion paint (satin finish) and black. Sometimes I add Cadmium Yellow Deep and Chrome Green, too. I also use tester paint pots as they give ready-mixed clean colours, ideal for the underpainting.

The canvases I use are ready made and pre-primed and I give these a coat of flame-red matt emulsion for the background to give the painting a good colour key overall. This also means you can leave accidental areas showing through the painting to good effect.

1 ● Do the initial drawing

After the background has dried, it's time to paint the initial drawing. I do this using black paint, and use a fairly worn and pointed hog brush to lay out the outlines and composition. I also include some details, such as doors and windows on the houses.

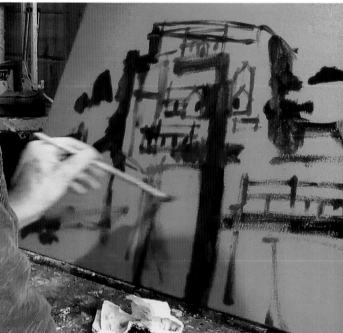

2 ◉ Tackle the underpainting

I now add in the colour. I use a round hog brush and paint quickly. For the houses and finer details, I use smaller synthetic brushes. The same colours are used in different places over the canvas to give unity and balance.

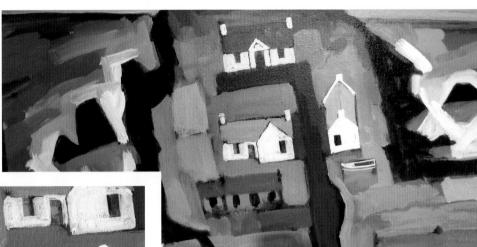

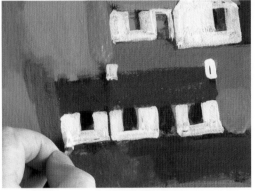

"Leave areas of canvas showing through the painting to good effect"

Splat!

Use cardboard boxes to build a splash booth. It will help keep all the mess in one place (rather than all over you!).

3 ◉ Add texture

Through pottery I've developed skills in working with texture and fluid glazes – techniques that I have also used in my painting. My trailing started off as pure texture using a grey paint on its own and was discovered by accident. I now use three main colours – cyan, mauve and red. I use a teaspoon to trail these paints.

4 ◉ Trail, flick and blot

The cyan and mauve colours are satin Berger paints I get mixed because they trail easily. However, the red is stiffer and more flicked about rather than trailed. It's a random process and any larger blobs are sponged off, as these would become too dominant. I work from top to bottom mostly, but I will use newspaper to mask off areas (such as the sky), and repeat the process over that area in a different direction.

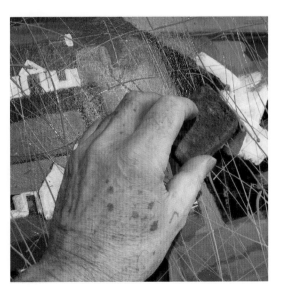

5 ● Work over the texture

I now do a second layer of painting – mostly with a palette knife where possible – using heavy body acrylics by themselves or with a mix of emulsion. The paint can be applied, then scraped back to reveal the textures underneath. Accidental areas of background colour are left showing through. The small unifying flashes of red give the painting warmth. I do not paint up to the edges.

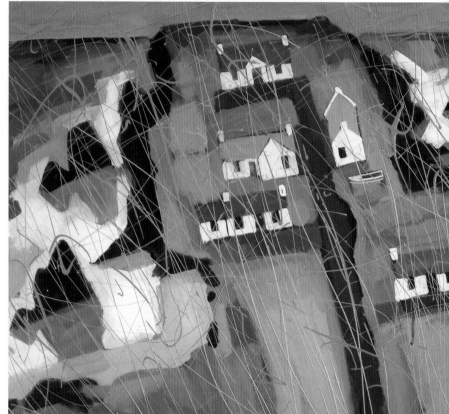

6 ● Layer colours

I now build up layers of paint, skimming them over one another to highlight the texture rather than making brush or palette knife marks. This offers a random texture that adds movement to the surface. To me, this suggests elements such as moving water, grass or wind and rain moving over the landscape. I am an impatient painter, so I use a hairdryer to speed up the drying process.

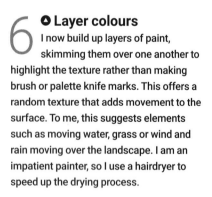

7 ● From dark to light

The red background darkens the initial underpainting, so even the same colour applied again will appear lighter. As the colours are built up I work from dark to light. This brings out the texture to its best affect. The layers can be either a lighter version of the same colour or something completely different depending on what I'm trying to achieve or suggest.

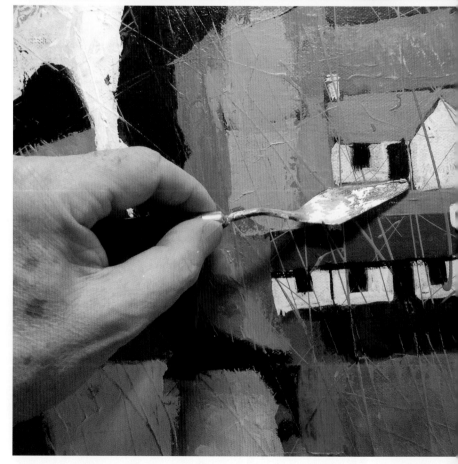

On the shelf
I use old Formica shelving for a palette. To remove any dried-on acrylic paint lightly sponge on some water, and leave to soak for five minutes. You can then use a scraper to remove it.

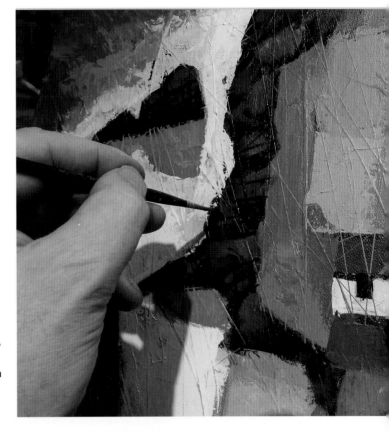

8 ◉ The detail

I paint as much as I can with a palette knife but for fine lines, such as the rock cracks, the seagulls and windows and doors in the houses I use a very fine liner brush. These behave like a pen as they hold a lot of paint that is fed into a fine point.

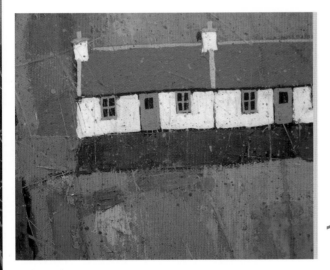

9 ◉ Do more flicking and splattering

I take a stiff hog brush and load it with colour to flick over the canvas in selected areas. I use the three colours to start with and then add any colour I feel will give accent to certain areas. The final part is to use a watery mix of Alizarin Crimson, splashed on the canvas, then sprayed with just enough water to make it run. This highlights the texture in a different way and is more like glazing. I add in the seagulls afterwards.

10 ◉ Varnish the final piece

I find Golden MSA UV satin spirit varnish is the best for my work. It suggests on the tin that it should be thinned, but I get the best results using it as it comes. It needs to be used in a well-ventilated area. My studio used to be in the house, but because of the fumes, I now have a studio in the garden that was built last summer. This varnish also has UV-filtering properties to protect colours from fading.

Capture spring light in watercolour

A visit to Derbyshire's Peak District provides **Robert Brindley** with the chance to paint a rural springtime scene filled with crisp light and colour

S pring is a wonderful and exciting time of year. As we move from the cold, damp, and dull conditions of winter, many artists feel the desire to venture outdoors to paint the fresh colours of the new season.

However, many inexperienced painters return to the studio disappointed by their efforts. In many cases, failure comes from their inability to simplify the subject matter and also to reduce the overwhelming strength of colour.

In this painting, *The Bridge at Milldale*, I hope to illustrate how clean, transparent colour can be controlled to produce a more considered, sympathetic rendering of the British spring light. The importance of a solid drawing, composition, colour and especially the use of tone will be stressed.

I was attracted immediately to this subject for a number of reasons. The most obvious reason was for the quality of the light and colour, which I felt perfectly encapsulated spring. I also felt that the composition was sound where the banks of the stream provided a gentle lead in to the focal point under the bridge. In my painting I decided to reinforce the focal point with the introduction of two figures.

I'll be using the controlled wash method for painting atmospheric watercolours. This method begins with an overall loose and airy, wet-into-wet application of colour. When dry, the tonal relationships from light to dark are developed, before adding the final darks and details.

The reference photographs for this painting were taken on a crisp, bright day in mid-April, on a trip into the Derbyshire Peak District to gather subject matter.

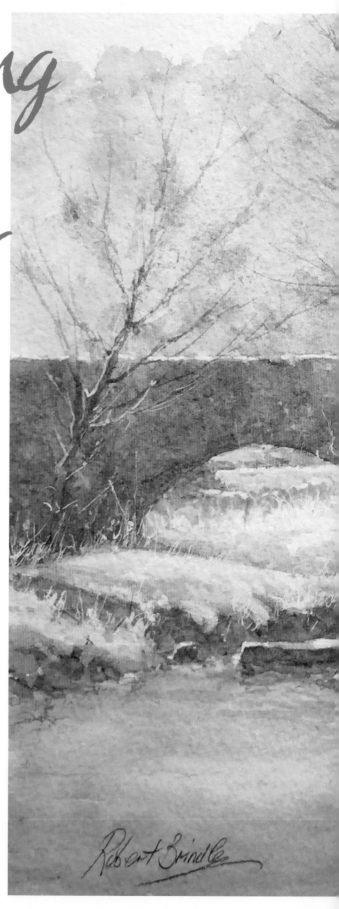

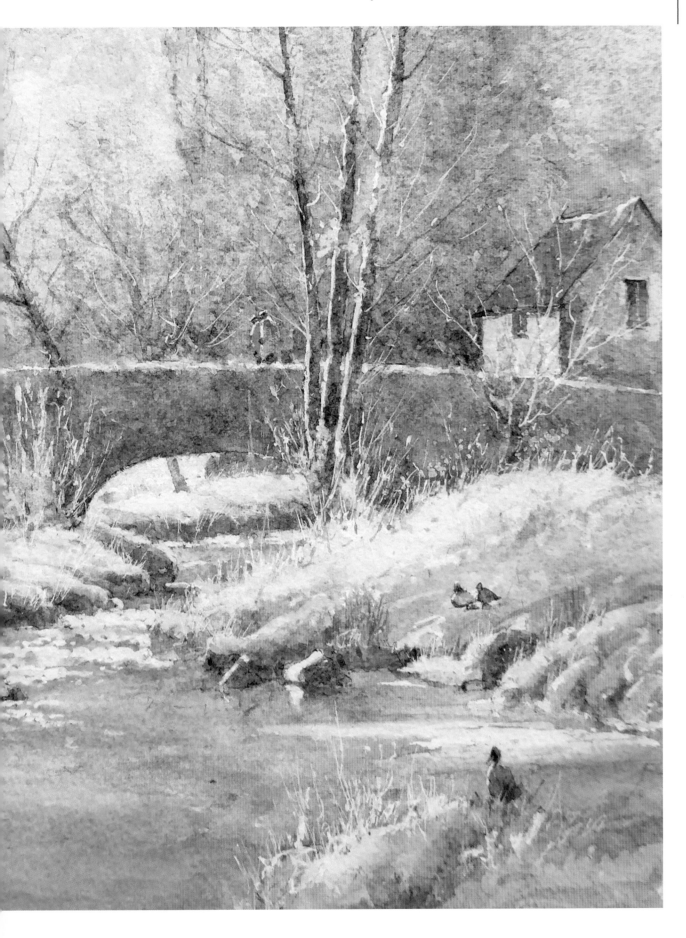

Materials

Robert uses these colours because they're perfectly suited to replicate the subtleties of the UK landscape.

- Winsor and Newton (Professional Water Colour range): Raw Sienna, Aureolin, Burnt Sienna, Raw Umber, Cobalt Blue, Cerulean, Ultramarine Blue, Permanent Magenta and Cobalt Violet.
- Paper: Arches (300lb).
- Brushes: Escoda Perla (4, 8 and 12). Pro ARTE Acryix (2 and 4). Pro ARTE Rigger (2).
- Masking fluid.
- Water spray diffuser.
- Toothbrush.
- 2B pencil.

1 ● Start with a good initial sketch

A carefully considered drawing is essential to enable me to place the initial loose, wet-into-wet washes with confidence and accuracy. To preserve the most important lights and highlights, I use masking fluid applied with a number 2 Pro ARTE Acrylix brush. I always clean the brush thoroughly, immediately after use.

2 ◔ Prepare colour pools

I prepare pure colour pools using the following: Cobalt Blue, Cobalt Violet and Raw Sienna. These three colours are the basic primaries on which the entire painting is based. In addition, the following colours are also prepared using mixes of Aureolin, Raw Sienna, Cobalt Violet, Burnt Sienna, Cobalt Blue, Ultramarine Blue, Cerulean, Permanent Magenta and Viridian.

"A careful drawing is essential for placing washes accurately"

3 ◉ Do a diffused wash
I wet the entire surface and introduce the colours as quickly as possible, from light to dark. The result is a diffused wash. My aim is to place the colour accurately, hopefully replicating the subtle colour and tonal changes in the scene. I allow the colours to mix freely, while at the same time use the pre-mixed colour pools to adjust colour and tone as the washes are introduced.

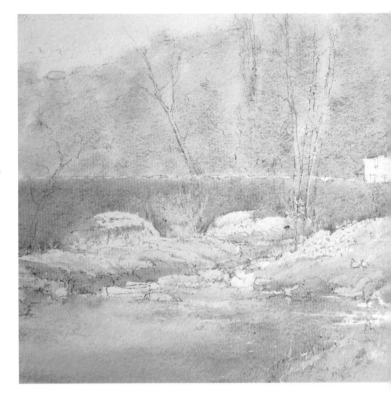

4 ◉ Paint the backdrop
I develop the distant diffused trees behind the bridge using the same colour pools. I want to achieve just the right level of resolution, so that when the nearer, skeletal trees are painted, the background doesn't compete for attention.

5 ▶ Remove masking fluid to reveal the lights

Now I remove the majority of the masking fluid with a clean finger. You should never attempt to remove masking fluid until the painting is completely dry. I then soften a few of the harsher edges left by the masking fluid to make them sit in naturally.

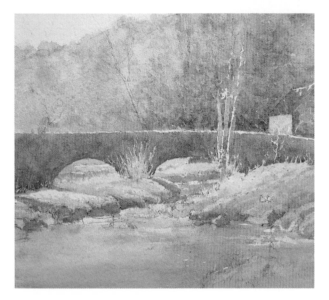

6 ▶ Develop tonal relationships

I start to develop the middle tonal relationships. Tone basically means how dark or light the colour is, and it's vital for the success of any painting. Without the correct evaluation of how dark or light any particular area of your painting is in relation to surrounding areas, everything will fall apart.

Tone is king

Tone is key to a successful painting. Colour, drawing and composition are, of course important, but if the tonal sequence is poorly observed then the painting won't work.

7 ▶ Paint the water

To ensure that the painting develops as a whole, I now turn my attention to depicting the water, and introduce wet-into-wet washes of Cerulean, Cobalt Blue, Cobalt Violet and Permanent Magenta. I make an effort to observe all of the subtle tonal changes that are present in the water. I purposely create a much darker area at the bottom of the painting – this helps to push the viewer's eye further into the painting.

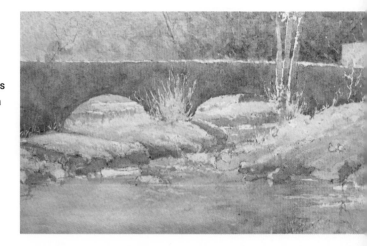

Take positives from failures

Nothing is ever learnt from a successful painting that almost painted itself. Always be positive, as far more can be learnt from your failures and mistakes.

8 ⊙ Paint the skeletal trees

I start to paint the trees using mixes of Cobalt Blue, Cobalt Violet and Raw Sienna, along with Viridian and Cobalt Violet that together make a wonderful grey/green. I'm careful not to overdo the number of branches and twigs in the painting – too many would detract from the overall effect. I also employ a lost-and-found approach, which I feel gives a more convincing rendering. From time to time I compare the number of branches and twigs in the reference photograph to what's developing in the painting.

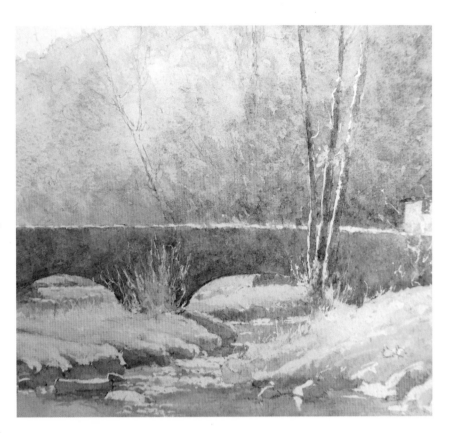

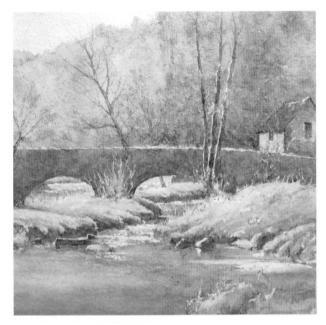

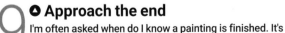

9 ⊙ Approach the end

I'm often asked when do I know a painting is finished. It's pretty much a gut feeling. At this stage I'm aware that the finish isn't too far away and that I must be careful not to overwork the painting. To complete this stage I work more on the skeletal trees and other details, together with giving more consideration to the darker tones present in the bridge, the banks of the stream and the cottage.

10 ⊙ Add finishing touches & evaluate

Time to add the final tones and details. This, for me, is the most exciting stage of the painting. However, without careful evaluation it can be the stage where everything can be ruined. Always think twice before committing to any addition. The fine details for this painting include small twigs and taller blades of grass. I also paint the ducks, introduce some daffodils and add two figures within the focal point.

Use a rich colour palette

Materials

Georgia is using a **ready-primed 30x30cm canvas**. This is a manageable area to cover if you're working from actual size. She also uses **Winsor & Newton oil paints**, **Pro-Arte short handle brushes**, and **Zest-It Oil Paint Dilutant and Brush Cleaner**. She uses bigger brushes for the background.

Influenced by the 17th-century Dutch Masters, **Georgia Cox** shows how to create a flower composition in a rich palette

Last year I visited an exhibition of 17th- and 18th-century Dutch flower paintings at the National Gallery. It was a breathtaking show and included work by the artist Rachel Ruysch. She was regarded as one of the most renowned flower painters, producing hundreds of exquisite paintings right up to her death at the age of 86. The thought of her always inspires me and it's great to find an artist that you can connect to in some way.

Rachel Ruysch worked with some complicated arrangements and a daunting level of technical expertise, but here I will simplify my painting – just selecting a few carefully chosen elements. To create your composition, find some interesting plants, twigs, fir cones, flowers, or visit your local florist for dried flowers. If you're just beginning, dried flowers are a great idea, as fresh flowers are forever changing and can be more difficult to capture. Also, working in oils offers the flexibility and time to paint the dried flowers, and once the paint is dry, you can paint over any mistakes.

For this workshop, I will use an arrangement from an old bouquet of roses and eucalyptus, all set against an exciting contrast of beautiful teal.

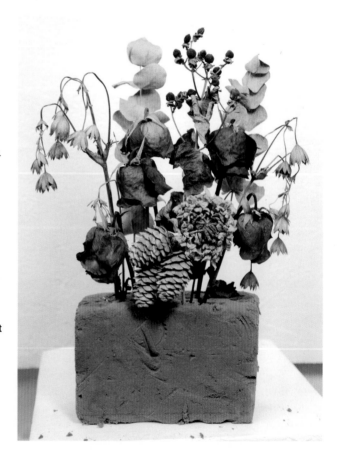

1 ● Create the composition

Arrange your plants. Here I've used a block of floral foam to put them in (this can be bought from florists). Play with the arrangement and mix it up a bit – you want a variety of shapes and colours, nothing too symmetrical. Ask yourself what the main focal point is going to be? Which colours work well together? Is the arrangement top-heavy? You're aiming for a well-composed harmonious effect.

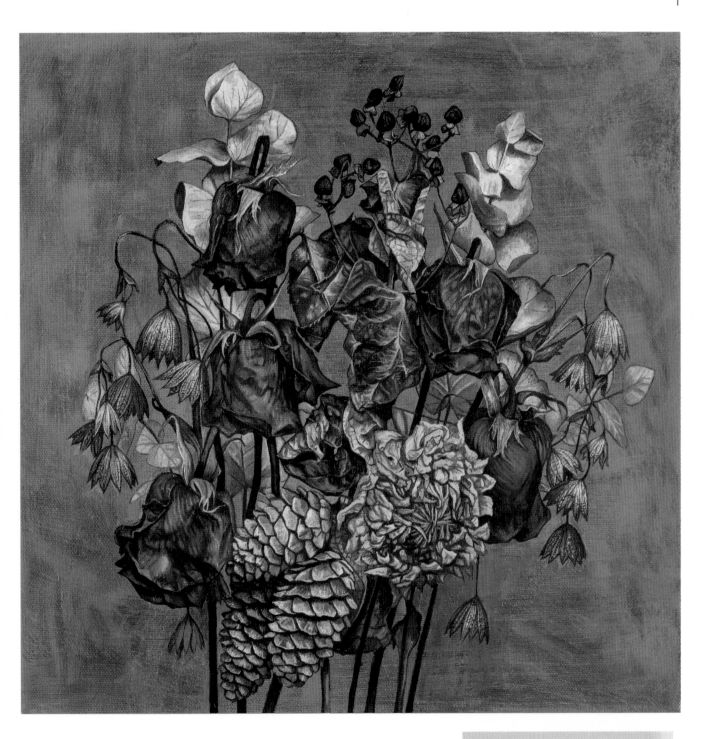

Straight up

Remove any dents in your canvas by lightly sponging just-boiled water over the back of it. The dents will instantly disappear like magic!

2 ◔ Place the larger elements

After your coloured ground is dry, you can roughly start to place the larger masses. I've started with the roses. You can keep rubbing out with your rag until you get it right. Check the placement of each element by holding up your paintbrush in front of your arrangement, as if you are following an imaginary plumb line.

3 ◔ Block in colours

With a larger brush, block in the dominant colours to get down the general shape and proportions. I've decided the yellow dahlia is going to be the focal point of my painting. Don't spend too long working on just one aspect – you may still have to change it.

4 ◔ Start to define edges

If you're happy that everything is where it should be, you can use a small brush to define the edges. Try to get a feeling for the nature of the plant. How does that stem join a leaf? Where do those petals overlap? Reserve the sharpest edges for the focal area of your painting.

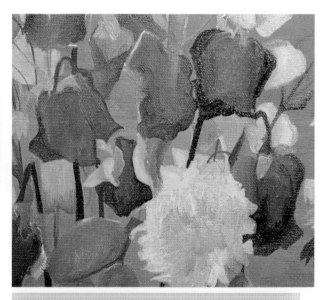

5 ▶ Add colour

Start to bring in colour. Once the paint has dried, you can add thin layers of colour over the top to build up rich hues. Try to avoid using pure black and white straight from the tube. If you like, you can accentuate some colours – here I've made my roses a lot pinker than they actually are.

Negative space

Pay attention to the negative space. This is the space that surrounds the object and the spaces in-between. It is as important as the subject itself. Giving yourself enough negative space will help give your subject more definition.

6 ◐ Consider shadows and light

Be aware of where your light source is coming from. Make sure you think about this when you're putting in the shadows. Shadows aren't black, rather they are darker and lighter values of colour within the shadow.

7 ◐ Create a smooth finish

Take some time to closely observe your subject. You want to convey the silkiness of a petal, the hairiness of a stalk, the crispness of a curled leaf. You can achieve a more realistic effect if there are no obvious brushstrokes and they are well blended (as seen in the paintings of the great Dutch flower painters).

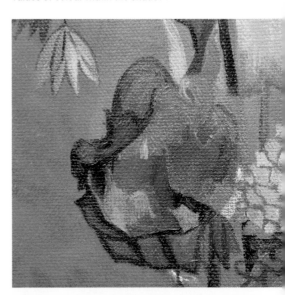

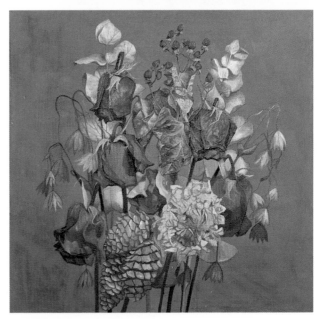

8 ◐ Work on small details

By now the colours should have been built up in stages, with the shadows all in the right places and the brushstrokes blended in. So now, using your smallest brush, add in the top layer of smallest details – tiny hairs, blemishes, the veins on a leaf. I've found that a miniature painting brush in size 10/0 works best for this.

9 ◐ Add highlights

When you're adding a highlight, try to avoid painting a hard line around its edge. Squint your eyes to see exactly what colour it is. Remember to mix colours into your highlights. No straight white from the tube!

10 ◐ Is it finished?

Cast your eye over the painting. Have you spent more time on some areas than others? Viewers will be able to tell which parts you've struggled with or haven't enjoyed working on. Have a look using a mirror to get a different perspective. Can you rework any of the problem areas?

Improve portraits with layers

Jake Spicer reveals how gradually adding detail will help you achieve a more engaging and accomplished portrait

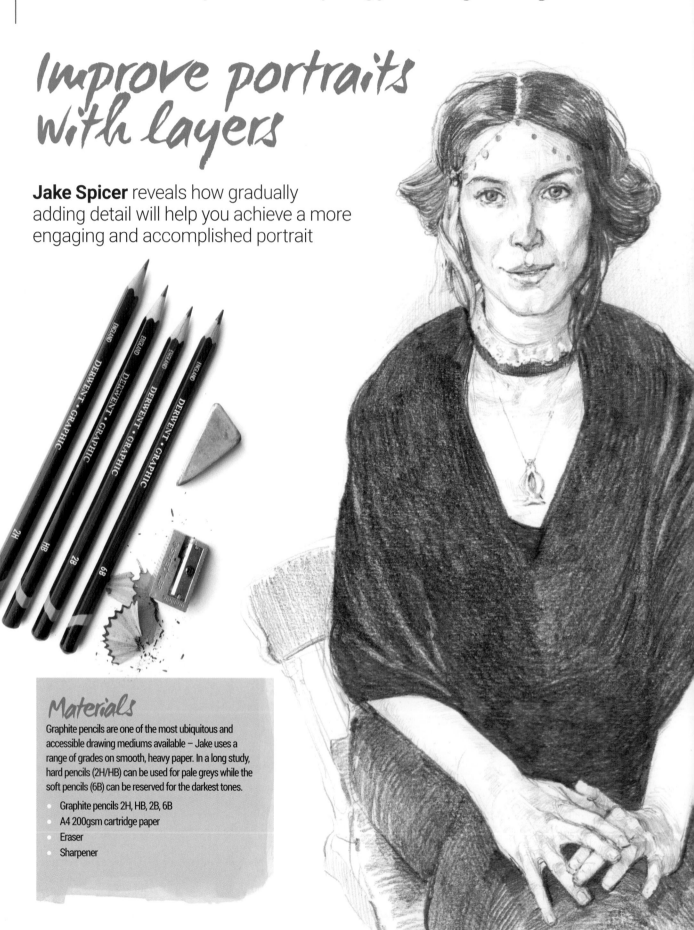

Materials

Graphite pencils are one of the most ubiquitous and accessible drawing mediums available – Jake uses a range of grades on smooth, heavy paper. In a long study, hard pencils (2H/HB) can be used for pale greys while the soft pencils (6B) can be reserved for the darkest tones.

- Graphite pencils 2H, HB, 2B, 6B
- A4 200gsm cartridge paper
- Eraser
- Sharpener

The best portrait drawings aren't just pictures of faces, but records of a long moment shared between artist and sitter. Whether you are able to ask friends or family to sit for a portrait, or can attend a drawing class with a model, it is always an engaging and exciting experience to draw another person from life.

If you don't have a sitter, set up a mirror for a self-portrait, and when necessary, you can always resort to working from photographs. The drawing in this tutorial was made over two hours from a combination of photographs of the model, Gigi, and sketches made during an hour-long portrait sitting.

There are many ways to draw a portrait and if you are aiming to improve your drawings it is important that you find an approach that works for you. Learning to draw is just like playing a musical instrument – it takes practise and application. As you develop your drawing, focus on improving your process rather than fixating on outcomes. The more confident you become in making clear observations of your subject and establishing a sound personal process for translating what you see into marks on a page, the better your drawings will be.

This tutorial will focus on a layers process suitable for those occasions when you can dedicate a little bit of time developing a

long study – starting with loose, light sketches that help you plan your composition and capture an impression of your subject, developing line later with tone added last. I always find the gesture of the hands add something significant to the portrayal of a face, so I have made this drawing a study of the whole upper body.

1 ⬤ Start with a sketch

Take some time to think about how you want to compose your sitter on the page – make a handful of simple, two-minute compositional sketches in 2B pencil to allow you time to look at your sitter from different angles and to arrange them in different compositions on the page before committing to a long study.

2 ⬤ Establish big shapes

With an HB pencil and a light, energetic line, establish the simple shapes of your sitter on the page. Avoid getting caught up in detail and aim to capture the shape of the whole figure in one or two minutes, paying particular attention to the proportion of the head to the shoulders. Lightly erase and re-draw until you are happy with the composition.

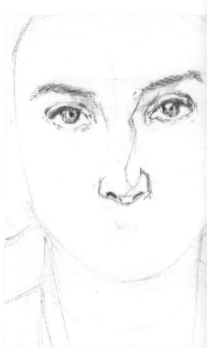

3 ◀ Add guidelines for facial details

The proportions of the face will affect the proportions of the rest of the pose – lightly erase your earlier sketch and dash in a line that would join both eyebrows, a centre line for the eyes, a line beneath the nose and a centre line for the lips. This is the scaffold on which you can hang the features.

4 ▶ Draw in the eyes and the nose

Lightly erase your construction lines and use a 2B pencil to draw in the shapes of the features as you see them – start with the sweep of the eyebrow and look at the distance between eyebrow and eyelash. Look out for the triangular relationship between the eyes and bottom of the nose as you draw, treating the long line of the nose simply.

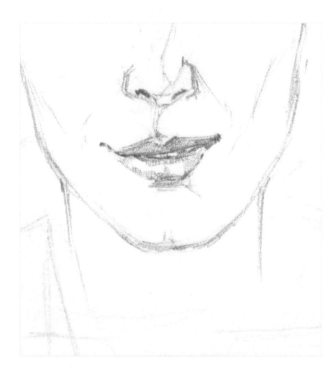

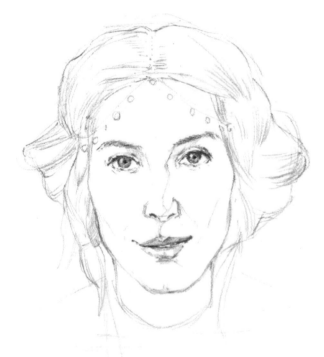

5 ◀ Work on the mouth and jaw

Spend more time looking at your model than at your drawing – when you draw the lips start with the dark centre line before drawing the lips themselves, lining up the corners of the mouth with the eyes above and making an expressive mark that captures something of the model's expression. Don't underestimate the size and importance of the chin and jaw.

6 ▲ Build up hair detail

The hair often defines the shape of the face and fills a large portion of the head – especially when seen in profile. Start with a simple shape first, building up textural marks in the direction that the hair is flowing. You can add further tone to the hair later in the drawing.

7 ⊙ Block in the hands

Once you are happy with the face, clarify the shapes of the body, leading down to the hands. Don't be intimidated by their complexity – start simple with the large overall shape of the back of the hand from wrist to knuckle and the space filled by the fingers, as if you were drawing the model wearing mittens.

8 ⊙ Flesh out the hands

Break up your big simple blocks by drawing the negative spaces that surround the hand – as you draw the triangular wedges of space between the fingers you'll find that you are defining the shapes of the fingers at the same time. Use a simple line to capture key shapes without giving undue prominence to fingernails and minor creases.

Fleeting expression

A photograph only has one expression – the one that was captured when the camera clicked. When you are drawing a model from life, be ready to record the fleeting shapes in the eyes, eyebrows and line of the mouth. All these make for a truly engaging portrait.

9 ⊙ Build form with light tones

Sit back from your drawing and make sure you are happy with the proportion of the figure. Use a 2H pencil to build up grey tones without going too dark, too fast. Add tone using confident, parallel hatching in the direction of the surface of the skin, using blocks of shadow to create the illusion of form.

"When drawing from life, be ready to record the fleeting shapes of the eyes, eyebrows and mouth"

10 ⊙ Dark tones

Finally, use a soft, dark 6B pencil to create striking contrasts in your drawing. Pick out the darkest shapes in the face and hands of your sitter, then build up masses of dark tone with blocks of parallel hatching, making use of the broader tip as the pencil blunts with use. If you need to, use your eraser to draw light back into areas that become too dark.

Paint your family in watercolours

Sue Sareen shares her methods for drawing and painting children using watercolour

With this workshop, I will explain the watercolour techniques I use to paint the young people in my family. It's important to practise drawing from life – this way you'll soon find your own way of translating from three dimensions to two.

Children will sit still for a while when watching TV, or playing on their computers, for example, and this will give you the chance to make a fairly detailed sketch. But it's worth remembering that even unfinished drawings will fix knowledge in your mind, and also enable you to use photos more successfully.

Materials

Sue uses **Bockingford watercolour paper, 300g, NOT surface**. She prefers this surface, as it's "not too smooth and not too rough". Bockingford is also more heavy than other papers, making it easier to sponge, and if necessary, remove paint. She uses **squirrel-hair mop brushes in sizes 2, 8 and 11**. These brushes hold a lot of water, enabling her to paint more freely, but at the same time "they keep terrific points". She also has a **small synthetic brush**, which can be useful when she needs drier, more precise marks.

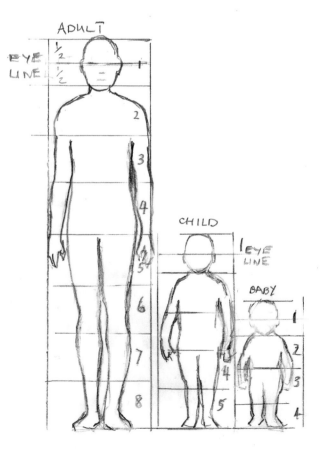

1 ○ Get the proportions

Note how the proportions of children differ from adults. An adult's body is roughly seven and a half times the length of its head, while a baby's body is roughly four times its head length. Note how the eyes of an adult are roughly situated halfway between the top of the head and the chin, and a child's eyes are lower. The eyes are large and the nose is small in comparison to the overall face.

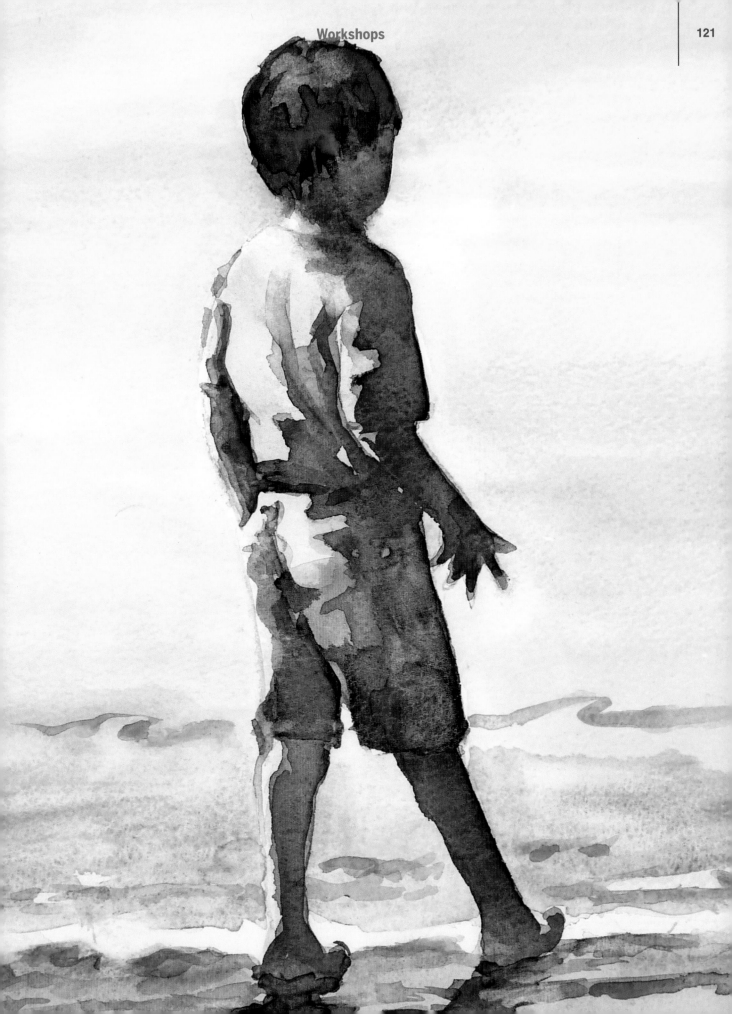

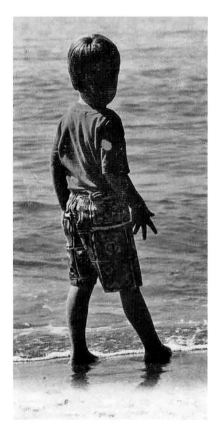

2 ◐ Start the sketch
Working from a photo, I lightly draw the figure onto the watercolour paper in pencil. I make sure I get the angle of the boy's legs, as well as his playfully splayed fingers. I leave extra space at the bottom of the paper to allow for the sea and sand, and notice how light comes from the left to create dark tones on the right of the figure. I will paint the picture working from light to dark, one layer at a time.

3 ◐ Paint in the tone
In this first tonal study, I aim to understand how the light affects the figure, creating highlights and dark tones. I use indigo for this – a clear, transparent inky blue. This is initially painted mainly as one layer, keeping the white of the paper to represent the lightest tones. Once this layer is dry, I add in darker tones. If necessary, I can add in even darker tones to create a third layer. You may need to increase the thickness of the paint to obtain a greater depth of tone for this.

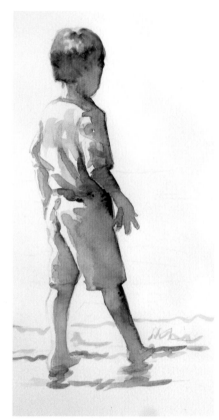

4 ◐ Adding in colour
With a pencil, I redraw the figure. Next, using a large brush filled with watery paint, I paint very light colours over it, changing the colours as I go. At this stage, I don't worry if the colours run into each other a little.

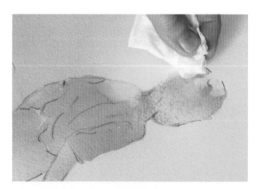

5 ◐ Blot to control
If you want to lighten any colours further, you can control the paint by blotting it with tissue. This both lightens, softens and dries the paper. Here, I'm keeping the colours light, so I can then paint in darker tones over the top of them.

Sitting-still lifes
Get into the habit of observing and sketching children. They sit still for longer while watching TV or playing quietly. Observe how they move when playing in the park, on the beach or wherever.

6 ◯ Paint the sand and sea

I now add sand into the scene, using Yellow Ochre mixed with a little Burnt Sienna. I add water to dilute and lighten the paint – this will make it fade out as it recedes into the sea. When this part is dry, using a large brush, I paint light tones of Cobalt Blue around and behind the figure. Some of the paper is left unpainted, to represent foam in the water. I wash blue over some of the foreground sand.

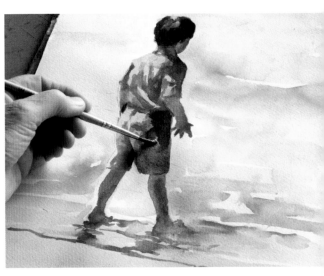

7 ◯ Add darker tones

Now that the paper is dry, I paint in the darker tones and shadows on the figure. I use a mixture of the original colour with another to make it darker, making the paint slightly thicker than the first layer. I also add in the tones and colour in the water, aiming to keep the background simple.

8 ◯ Add the darkest tones

I now add even darker tones where necessary, again making the paint slightly thicker. Increased contrast can really liven up a picture, making it more dramatic.

9 ◯ Allow the colours to run

Occasionally, it's useful to tip the board and painting while the paint is wet. This allows the colours to run into one another and mix a little on the paper.

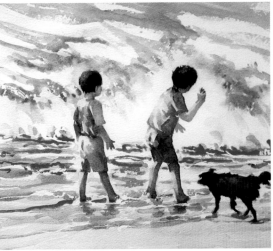

10 ◯ Move on

Having mastered one figure in watercolour, it's now possible to add an additional figure or two (or maybe a dog), and further develop the waves and beach. Painting the sea is another challenge, and would be another exercise in its own right!

Paint like... Monet

Rob Lunn guides you through a study of Monet's winter scene 'The Magpie' from start to finish

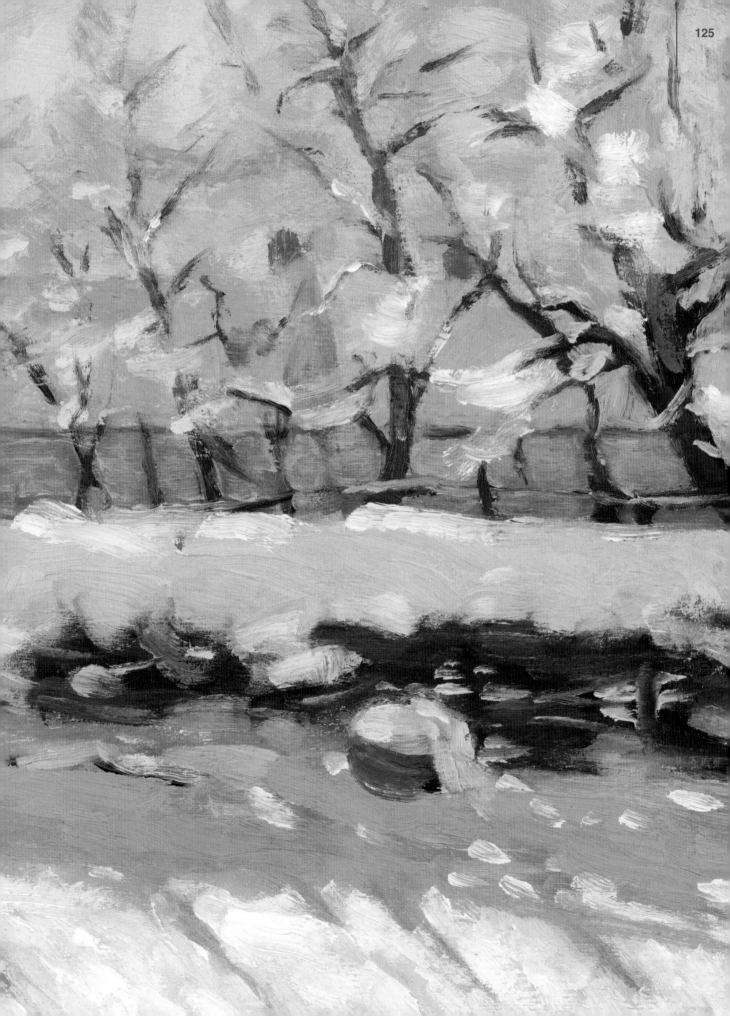

Materials

The colours used offer a good representation of the colour spectrum while retaining the most saturation when mixing.

- Michael Harding Oil Paints: Ultramarine Blue, Blue Lake, Green Lake,Bright Green Lake, Bright Yellow Lake, Yellow Lake, Yellow Lake Deep, Permanent Orange, Scarlet Lake, Alizarin Crimson, Magenta, Ultramarine Violet, Titanium White
- Acrylic-primed 3mm MDF board, 6x8in
- Rosemary & Co. Ivory short-handled Filberts, sizes: 0, 1, 2, 3, 4, 5
- The Masters Brush Cleaner and Preserver
- Bartoline Brush Cleaner
- Kitchen roll

With this masterclass we will attempt to get inside the head of Monet a little, so we can think and paint in his style. But, don't worry, we're not trying to fool the Wildenstein Institute (the family that decides what is and what isn't an authentic Monet original). However, there are still painters working today who can trace their taught method right back to Monet himself, so we still have a good idea of his approach and how he painted. Saying that, don't forget that even though we're using a masterpiece as our inspiration, it's important to let your own marks shine through. Here, we're going to dissect and analyse Monet's painting method, looking at how he applied his paint – but because *you* are the one painting it, there's no need to get bogged down by trying to replicate every single brushstroke. Observe and evaluate, but don't miss the bigger picture.

We'll start by setting up our workspace and equipment. Then we'll work our way through the painting step-by-step, breaking the process into digestible chunks. The long drying times of oils (and also its sculptural qualities) gives the paint huge advantages over other mediums, but the workshop could also be adapted for acrylics, watercolour, pastels or even pencils.

One last tip – try not to think too much about the finished painting and try to see each stage as an end in itself. Enjoy the moment of creating each one. Expectation and pressure can often affect creativity and confidence, especially when faced with the daunting task of re-creating a famous work of art. For now, let's enjoy experimenting with the beauty of Monet's style.

1 ◑ Lay your ground

Spend a bit of time getting everything you need close to hand. Working from a photograph (or an original) saves on some of the set-up, but you still need to plan ahead. The Impressionists famously worked directly onto white canvas, but they also used grounds when necessary. As there are so many chilly blues and greens in Monet's *The Magpie,* I've chosen a pink acrylic ground that will add a bar or two of warmth, and will especially help boost that magnificent winter sunlight....

2 ▶ Start on the gesture drawing

Once your ground is dry, you can start on the gesture drawing. We're testing and getting a feel for Monet's composition with this simple charcoal sketch, much like a dress rehearsal. Don't forget that even though we're copying Monet's painting you're still free to change elements if you wish. Now is the time to test your inspiration! Once you're happy with your gesture drawing, you'll be wiping it all off ready for the next stage.

3 ◐ Construct

Now use a dry-brush technique (take a little paint on your brush and wipe it a few times on some kitchen towel – you want it to be as dry as possible) to construct over your gesture drawing. I've gone for a very cool black that I've mixed myself from Alizarin Crimson, Blue Lake and Bright Yellow Lake. Remember that every new brushstroke should be from fresh observation. Quick, simple and full of life is key to this stage, just try and identify the main elements in your composition.

4 ◐ Pre-mix colours

It's not an exaggeration to say that at least 50% of your painting will be done in this stage. If you don't believe in pre-mixing then I urge you to give it a go. It can be frustrating at first, but it gets quicker with practice and it prevents any notion of 'it'll do', which is common when your colour scheme is not prepared. Spend time getting your colours right and you'll reap the benefits later. You won't mix every colour, but you'll be starting off on the right foot.

All white!

White is actually a very very *very* light blue... So when you're adding it to colours to make them lighter you need to keep this in mind. Adding white to a mix will always desaturate colours, especially those on the opposite side of the colour wheel to the blues, e.g. the yellows and oranges.

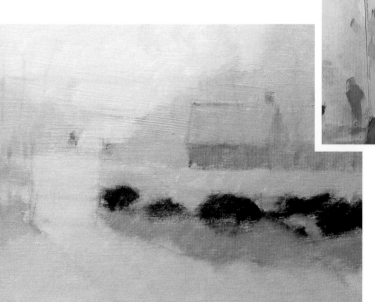

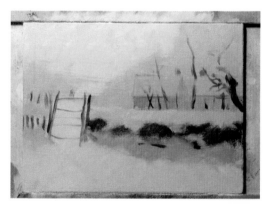

5 ⊙ Build up darks and mid-tones

Using the dry-brush technique again, start to add your darks and mid-tones with a scrubbing action (forefinger on top of the ferrel with the end of the brush running under your wrist). It's tricky in a painting such as *The Magpie* because there's so much snow, but try your best to plan out your tonal range. Keep squinting to simplify the tonal range you see and start with the larger areas. Tweak your colours if necessary and play around with the balance of light, dark and mid-tones until you're happy.

6 ⊙ Reconstruct

With so much light (0–35% tone) in our painting, there aren't many tonal differences to define with the reconstruction stage, and so planning out the composition can be tricky. Nevertheless, keep your lines quick and full of energy and keep them fun. See this as bringing back a bit of definition to your foundations. Always take the opportunity to observe again and measure again – don't be scared to correct if needed!

7 ⊙ Release the colour

Using fuller and more loaded brushstrokes, release the pre-mixed colours onto your painting. You've done plenty of prep, so it's time to trust the process and gorge on some colour! Keep observing your source and keep checking your tonal scale, but take time to enjoy the simple pleasure of applying all that lovely paint. Don't be worried if your painting doesn't 'appear' straightaway – keep to the large shapes to begin with and once they're all in place you can start adding more layers of detail.

In the know

Monet started his artistic career as a talented caricaturist poking fun at his elders. Although they were fun, his pencilled caricatures completely go against the monumental effect he would later have on the history of art.

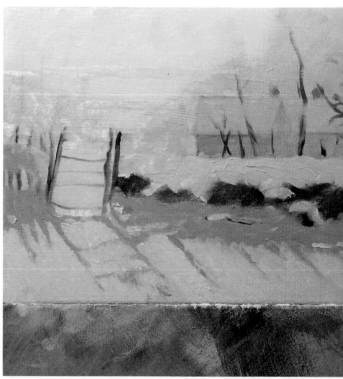

8 ◐ Think tonally

Monet spent a lot of energy observing tone and laying it down brushstroke by meticulous brushstroke. To follow in his footsteps, use a tonal scale to measure and test the tones you're viewing, mixing and painting. Squinting helps break down the range of tones you're able to see and so simplifies the image. Start with the large shapes and add more observed detail as you go. *The Magpie* is mostly light (0–35%) with a secondary bias to mid-tone (35–65%) and just a small amount of dark (65–100%). It creates an airy and almost magical feel to the painting.

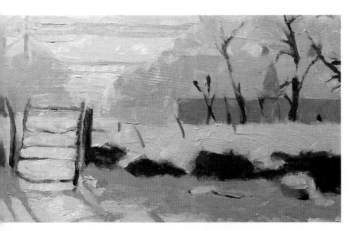

9 ◓ Observe Monet's brushwork

Monet described himself as just 'an eye'. Viewing his paintings was intended to be a personal experience – you were not just seeing the gate, tree or haystack that Monet saw, you were seeing the atmosphere, the air and space between his eye and his subject. He applied his colours as dapples of light streaming across his paintings. They were fleeting moments that sometimes took weeks to capture. Follow where your light is travelling through your painting and describe it with your own dappled strokes. Have fun and experiment.

10 ◐ Begin to fine-tune

Once your larger areas are in place, you can start to add layers of increasing detail. Try not to get lost in the repetition of brushstrokes, keep looking back at your source and checking your tones and colours. Try to look for repeating colours (colours that share each other's spaces) that create harmonies throughout the painting. Try and hold off applying any really fine detail until last – and remember knowing when to stop is an art in itself!

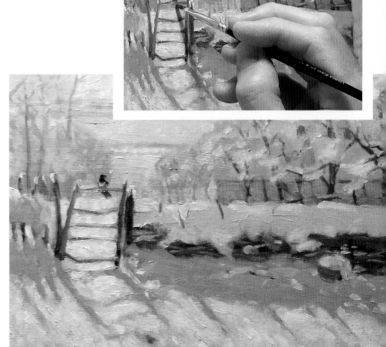

Top tip

Monet loved dappled brush marks, but it's hard to keep them looking fresh over large areas. Don't just repeat, always look for the way the light travels across the forms and then describe them using your dapples.

Paint like... Cézanne

Rob Lunn guides you step-by-step through an interpretation of Cézanne's painting method from initial sketch to final flourish

P aul Cézanne was known for his experimental style, always pushing to expand the viewer's experience of conventional subjects. Here, we'll observe his painting method, with blocky, stabby brushstrokes and muted notes that emphasise his eye for colour. We'll try to re-create a painting with the feel of one of his works. Notice I don't say "copy" – we want to be inspired by Cézanne, not slavishly knock out a version of one of his paintings. Brushstrokes are like handwriting. We all have our own individual marks and it's important to recognise this and embrace it.

I paint in oils because I love the freedom they offer, with long drying times and sculptural qualities. Portraiture is my main passion and I always like to add a bit of character to my still-life elements too. This gives them personality and informs the way I paint them.

We'll leave the composition simple so we can concentrate on technique. Feel free to add any still-life elements you wish, but I'd advise staying away from any objects with a very decorative finish.

We'll start off by setting up our scene and getting ourselves prepared. Then we'll work our way through the painting step by step, breaking the process down into easy-to-manage chunks.

Materials

Rob likes these oils as they're realistic colours and retain the most saturation when mixing.

- Michael Harding Oil Paints
- Acrylic-primed 3mm MDF
- Rosemary & Co. Ivory short-handled Filberts
- Kitchen roll
- The Masters Brush Cleaner and Preserver
- Bartoline Brush Cleaner

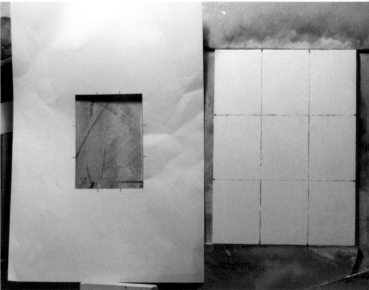

1 ○ Get the setup

Make sure everything you need is close to hand. A viewfinder can be fashioned from A4 paper and used to aid drawing and composition. I added marks to break the height and width into thirds. This can then be relayed to your panel if you feel less confident drawing accurately. Play with your objects and lighting to see what different effects you can create. Move elements around until you're happy.

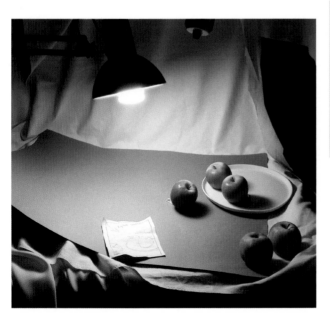

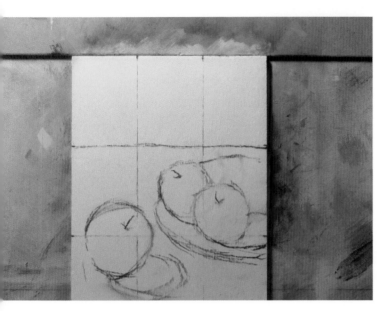

2 ○ Make a gesture drawing

First make a gesture drawing using charcoal. This is like a dress-rehearsal for your composition – it's much easier to rub charcoal off than paint. This drawing should only be about the placement and general flow of objects, plus marking out any big divisions in tonal value. Keep your marks light and energetic. Once you're happy you'll be wiping it off, so get your composition working now.

3 ○ Construct the image

Now re-create your gesture drawing, but in oil paint. Use a dry-brush technique – take a little paint on your brush and wipe it a few times on kitchen towel, so it's as dry as possible, and sketch your composition back in. Don't just copy the charcoal lines; take this opportunity to remeasure and retune your drawing. Identify the main blocks of tonal value and colours again. Keep it simple, quick and full of life.

4 ○ Pre-mix colours

It's a good idea to pre-mix as many colours as you think you'll need before you start painting. You'll obviously mix other colours as you go, but this is a good start. Hold a little of the colour on your palette knife up to the subject in place. You'll get a better idea of accuracy under the correct lighting conditions. To keep colours brighter, mix together complementary colours around the colour wheel instead of automatically reaching for black or white.

Great idea!

Try squinting at your subject. This will break down the different levels of tone and colour, and it can stop you getting swamped down with too much detail, especially at the beginning of a painting.

5 ◐ Build up darks and midtones

You can now apply colour. Using a dry brush with a scrubbing action (forefinger on top of the ferrule, with the end of the brush running under your wrist), work in the mid and dark tones. Squint, measure and adjust as you go. Keep it light and don't worry about staying within your construction lines. You can see this technique in action in Cézanne's unfinished *Still Life With Water Jug* (circa 1892-3).

6 ◑ Think tonality

Tone is vital to a successful painting, and knowing how to manage it is an important skill to practise. My composition is mainly midtone with a secondary bias to light and just a small amount of dark. It creates a fun and relaxed feel to the painting, reinforcing the angle we chose to begin with. Use a tonal scale tool to identify the tones and make sure you've got the right balance for the effect you want.

7 ○ Reconstruct construction lines

Next, reconstruct your construction lines and redefine the tonal areas. Remember to keep the lines light and energetic, and take the opportunity to remeasure and reassess your composition. Always be ready to change an element if it isn't working. Its adaptability is one of oil paint's most useful qualities. Don't be afraid to wipe or scrape back and start again, if you need to. A scrunch of kitchen roll has saved many a painting from disaster!

8 ○ Release the colour

With fuller, more loaded brushstrokes, begin to apply your premixed colours, but be ready to adjust them as you go. Work in large shapes to begin with. At this stage things can sometimes seem a little clumpy. If your painting doesn't immediately appear in front of you, trust the process. Keep squinting at your subject, stand back now and then, and keep your kitchen roll close at hand. Be open to change.

9 ◉ Re-create Cézanne's brushwork

Cézanne loved to create intricate patchworks of colour and balance them off with stabby, energetic brushstrokes. He often gave his still-lifes quite solid outlines, repeating the reconstruction phase later on in the painting. An outline defines a form so solidly that even a humble apple can stand out next to decorative jug or armless cherub. Have fun playing with your brushstrokes to see the effects.

10 ◉ Begin to fine-tune

Work into the larger areas and add layers of detail as you go. Look for unusual colour details that pop out. Cézanne liked to make a feature of these, so run with them if you spot them. Strong colours will bleed out into their environment, and adding touches of complementary colours next to each other will help the colours sing. The last touches should be the highlights.

Paint like... vanGogh

Rob Lunn reveals how to build up a self-portrait from initial charcoal sketch through to finished oil painting

Dutch post-impressionist, Vincent Willem van Gogh (1853 –1890) created many self-portraits in his career, and some of them are not so obvious. For example, *Irises*, painted at the Saint Paul-de-Mausole asylum in Saint-Rémy-de-Provence in the last year before his death, is a perfect example. A white flower stands alone and defiant in this very moving painting.

The self-portrait can take many guises and gives the artist the opportunity to say something about who they are, what they are, and importantly, what and who they want to be. In this workshop we're going to go through the stages of developing a self-portrait from start to finish and also try and give it a hint of the great master, Vincent van Gogh.

Materials

Rob has used the following colours because they offer "a good representation of the colour spectrum while retaining the most saturation when mixing".

- Michael Harding oil paints: Ultramarine Blue, Blue Lake, Green Lake, Bright Green Lake, Bright Yellow Lake, Yellow Lake, Yellow Lake Deep, Permanent Orange, Scarlet Lake, Alizarin Crimson, Magenta, Ultramarine Violet, Titanium White, Yellow Ochre, Alkyd Burnt Sienna, Alkyd Blue Lake (Griffin Phthalo Blue)
- Acrylic-primed canvas board, 10x12in
- Rosemary & Co. Ivory standard-handled Short Flats (sizes 0, 2, 4, 6, 8 and 10)
- 0.8mm Schmincke Aero Color liquid acrylic marker
- A mirror and stand

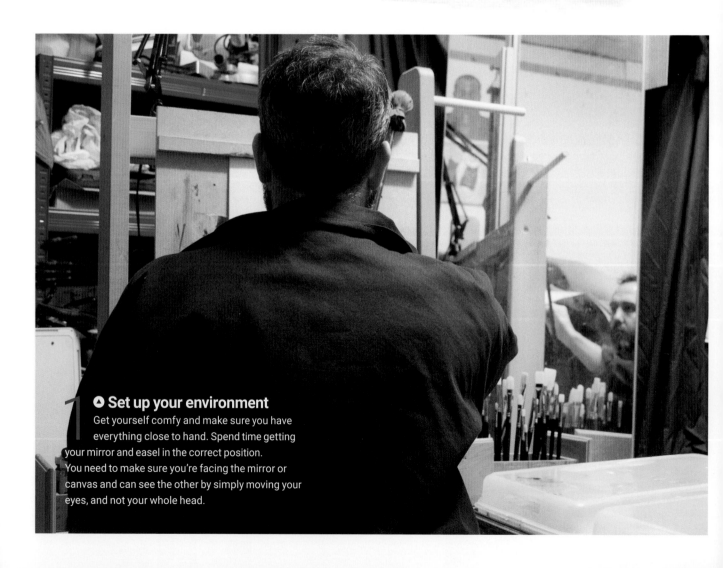

1 ◔ Set up your environment

Get yourself comfy and make sure you have everything close to hand. Spend time getting your mirror and easel in the correct position. You need to make sure you're facing the mirror or canvas and can see the other by simply moving your eyes, and not your whole head.

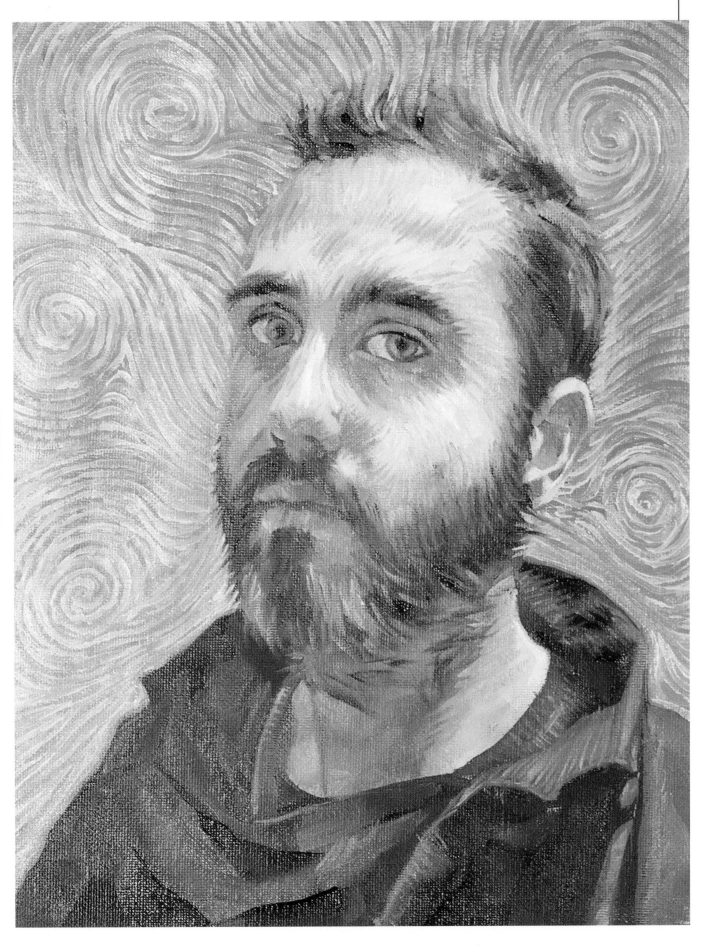

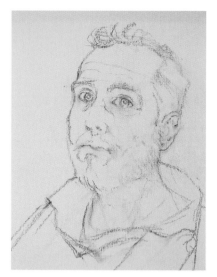

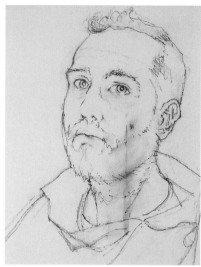

3 ◑ Add Construction lines
I fix the drawing in place using a liquid acrylic marker. I've chosen a purple acrylic ink for my construction lines, but an earthy red or blue would work just as well. Just as long as the colour is dark enough to show through the tonal stage that's coming up next.

2 ◑ Do a charcoal sketch
Using a sharpened stick of willow charcoal start to sketch the main features in. Remember to begin with the larger forms and add increasing levels of detail as you go. This is just a dress rehearsal, so don't worry about adding form shadows. However, it'll be helpful to add the extreme edges of cast shadows at this stage.

4 ◑ Create a tonal painting
Creating a tonal stage helps break down the painting process. When I'm thinking about tone, in this case Alkyd Burnt Sienna thinned down with a little bit of turps, I'm not thinking about colour at all. I'm just concentrating on tone, which I'll use as a guide when I get to releasing the colour later.

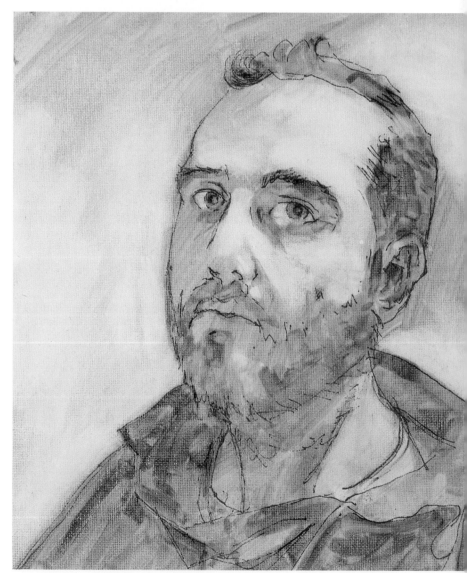

5 ◗ Pre-mix your colours

I start by mixing a base tone for my skin using Yellow Ochre and Scarlet Lake, along with a touch of Green Lake to knock the scarlet back. This orange-brown is then lightened for skin tones and darkened for shadows. I also mix my own black from Alizarin Crimson, Blue Lake and Bright Yellow Lake and create greys to mix with the skin tones.

6 ◗ Block in the composition

I begin to block in the main areas of light and dark. Squinting my eyes helps me to keep this stage as loose as possible, to retain a feeling of spontaneity as colour goes on the panel. You'll be working more into this, but the brush marks you make now will inform the ones you make later, so start off on a good footing!

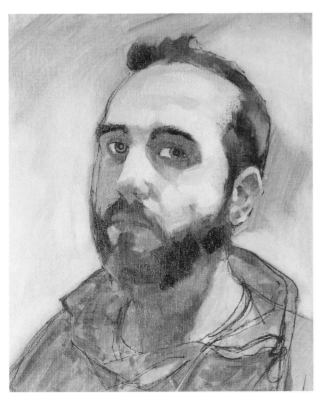

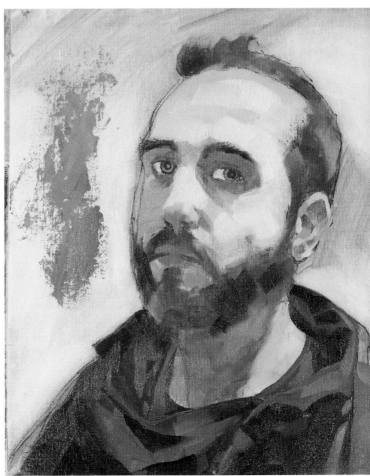

7 ◗ Add more detail

Once I've established the main areas of light and dark in the face, I break them up into further areas of different tone and colour. I also start to block in the torso and look at a colour to use for the background. Allow yourself to experiment at these early stages.

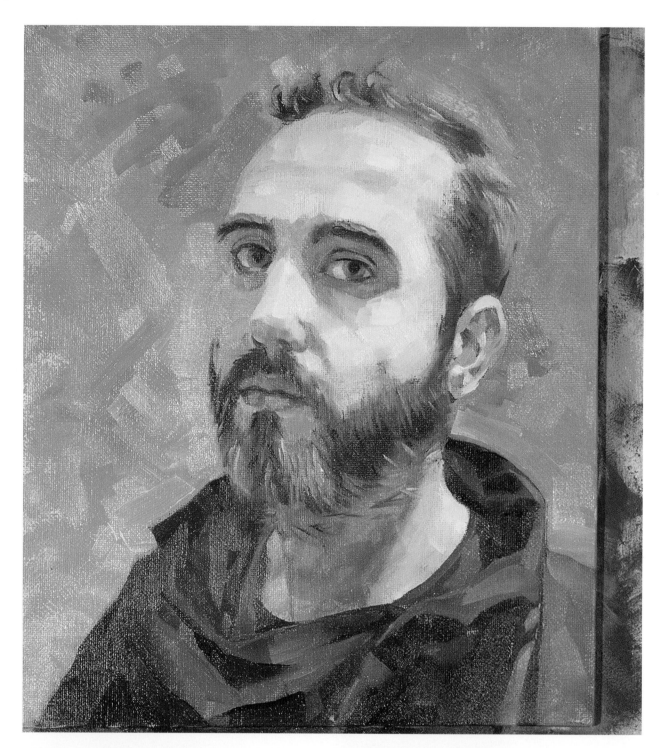

8 ⬤ Unify the elements

You should aim to have all of the canvas worked at this stage. You need to see the painting as a whole and judge how the tone and colour of each area relates and affects each other, even if you still need to add further details to certain areas.

9 ▶ Add some van Gogh

Now that I have my base, it's time to bring in some touches of Vincent. This painting is mainly based on a self-portrait Vincent painted in Paris in the summer of 1887 before he moved to Arles, so he's still heavily influenced by the Impressionists, and Pointillists in particular.

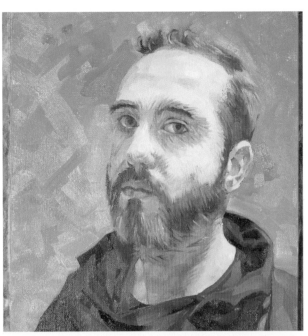

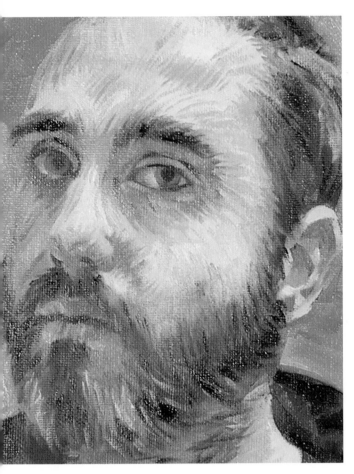

10 ⚙ Add dabs of colour

Using the blocking-in as a guide, I apply Vincent-style dabs of colour, allowing the brushmarks to follow and describe the form as I go. I pay close attention to areas of dramatic shift in tone: they enable me to create some interesting and bold marks. When trying this for yourself, look out for colours that jump out at you, and don't be afraid to exaggerate these for effect.

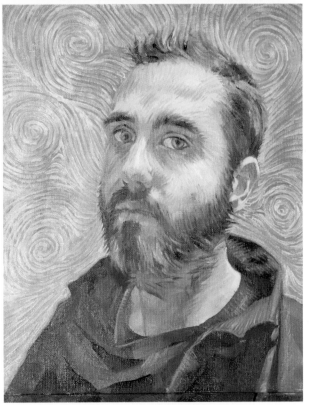

11 ⚙ Fine-tune and finish up

When adding details, knowing when to stop is an art in itself, so hold off adding highlights until the very end. Try not to work over areas too much. If there's a problem just scrape it off and try again. You should have plenty of pre-mixed colours left – remember you don't have to use them all!

Hearing aid!

Listen to music or audio books. They can help keep the logical part of your brain busy while painting and this frees up your creative side to get really stuck in!